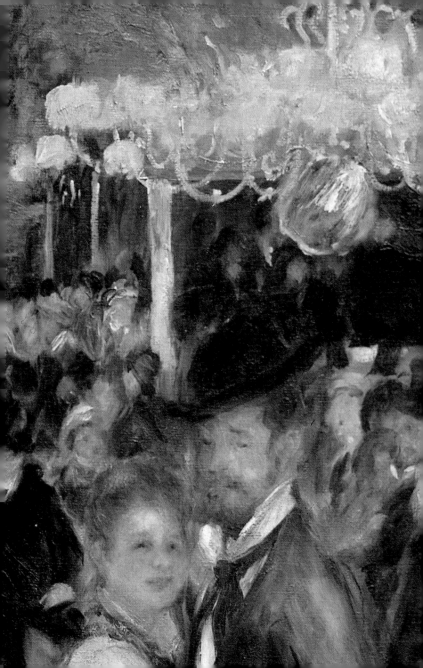

CONTENTS

RENOIR
A SENSUOUS VISION
Anne Distel

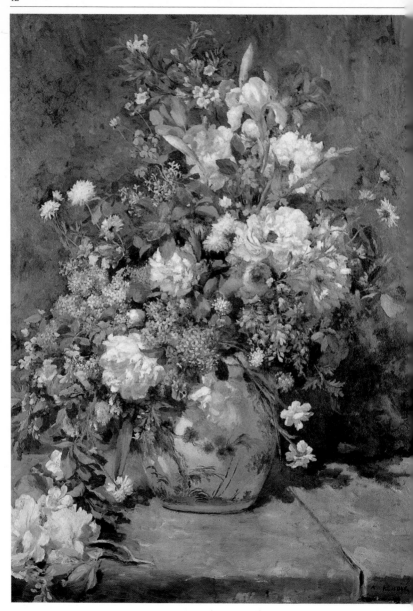

I'm like a piece of cork thrown in the water and carried by the current. I let my painting take me where it will!' Renoir's life, unlike that of other artists, is reflected in his paintings and revealed to the public, whether he will or no. 'I don't think I've let a single day go by without painting,' he noted at the end of his life.

CHAPTER 1

ACCEPTED OR REJECTED?

One of Renoir's earliest known paintings is this still life of flowers, dated 1858. Among his last works – in 1919 – are flowers yet again. In between, he never tired of this traditional subject, which he reinterpreted according to his evolving style. This *Vase of Flowers* of 1866 was painted for one of his earliest collectors and patrons, the architect Charles Le Coeur.

Pierre-Auguste Renoir was born in Limoges, France, on 25 February 1841, the next to last of seven children. Two of them died in infancy, the only bit of drama – and a commonplace one for the time – in the history of a poor but hardworking family. His father, Léonard Renoir, was a tailor, his mother, Marguerite Merlet, a dressmaker. The family soon moved to Paris, to the neighbourhood of the Louvre, first on the Rue de la Bibliothèque (which vanished when the Rue de Rivoli was rebuilt), then to 23 Rue d'Argenteuil.

Apprentice at thirteen

The young Auguste loved to draw. The example of his brother Henri, ten years older and an engraver of heraldry, encouraged him, as did that of his brother-in-law Charles Leray, also an engraver. Renoir's parents, unlike those of many of his future colleagues from a more middle-class background, not only did not try to oppose an artistic career but even encouraged it, eager to ensure his ability to earn a living as soon as possible. To this end, they apprenticed him to a porcelain painter when he was thirteen.

Until 1860, Renoir experimented with various decorative trades, painting fans, blinds and cupboards. While he proved extremely good at such practical work, it could only have whetted his desire to escape from such drudgery.

The Ecole des Beaux-Arts

He then set off down the traditional path that all who wished to become painters followed at the time.

When he was still an apprentice porcelain painter – the elaborate vase below is one of the few pieces of his that are known – Renoir roamed his neighbourhood and discovered the Fountain of the Innocents, with Jean Goujon's *Nymphs* (1547–9, above), whose classical elegance appealed to him.

By January 1860 he had obtained a pass that enabled him to copy in the Louvre, and on 1 April 1862 he was accepted to the Ecole Impériale et Spéciale des Beaux-Arts. Except for two brief interruptions incurred while doing his military service, Renoir attended his classes regularly, earning respectable grades but not even approaching the level of the Prix de Rome, the five-year scholarship to study in Italy that was the ultimate stamp of approval. It is highly unlikely that the official line of teaching, long bogged down in its devotion to antiquity, based on an apprenticeship in drawing, and dependent on the lessons of perspective and anatomy, had much in common with his ambitions.

B elow left: a note on the back of this amusing collection of portraits of the students in Gleyre's studio indicates that Sisley's is the third face from the left in the same row as the man with the halo. The clean-shaven man shown in profile just below him would be Renoir, painted by his friend Emile-Henri Laporte, facing Renoir, who painted him in turn.

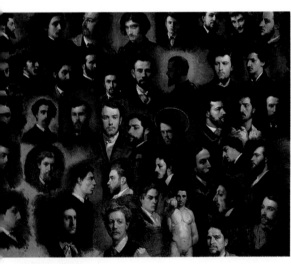

A bove: this 1861 photograph is the only known image of the young Renoir. The artist always remained very reticent about his personal life. 'I'm horrified at the thought of the public knowing how I eat my cutlet and that my parents were poor but honest,' he wrote. 'Painters become very boring with their pathetic stories, and no one gives a damn about it.'

Gleyre's studio

From 1861 Renoir began to work in the private studio of a Swiss painter, Charles Gleyre. Gleyre's relatively liberal and impartial approach to teaching, rather than the quality of his painting itself – grounded as it was in tradition – attracted many students to his studio. Among them was a young man from Montpellier, Frédéric Bazille, who joined near the end of 1862, and one from Le Havre, Claude Monet, as well as Alfred Sisley, the son of a Parisian merchant, all of whom soon

became friends of Renoir's. None of them was happy with traditional teaching methods; their tastes were varied, ranging from a master who died in 1863, Eugène Delacroix, to the newly arisen – and still highly controversial – champion of realism, Gustave Courbet. They liked Camille Corot and hated Jean-Léon Gérôme and Alexandre Cabanel, the painters of the moment, but they were not without admiration for Ingres, who died in 1867. Another young painter, only a few years older than they, provided them with an encouraging example. Edouard Manet defied the forces of conservatism in exhibiting his famous *Déjeuner sur l'Herbe (1863)* at the Salon des Refusés.

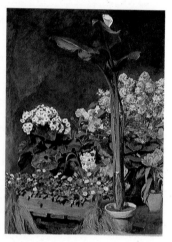

As its name ('Salon of the Rejected') implies, that unprecedented venue allowed the public the opportunity to see works that had been rejected from the official Salon. The jury that judged admissions to that official exhibition was largely dominated by powerful conservative academics.

Renoir at the Salon

Acceptance to the Salon, held in Paris every year, conferred a sort of seal of approval on the artists whose works were so honoured; they were duly rewarded by medals and the presentation of their works to prospective buyers at a time when few private galleries existed.

The bulk of the public, indoctrinated by this system largely endorsed by the critics, swallowed the jury's

EXPLICATION
DES OUVRAGES
DE PEINTURE, SCULPTURE,
ARCHITECTURE,
GRAVURE ET LITHOGRAPHIE
DES ARTISTES VIVANTS,
EXPOSÉS
AU PALAIS DES CHAMPS-ÉLYSÉES
LE 1er MAI
1864

Prix : 1 Fr. 50 c.

PARIS
CHARLES DE MOURGUES FRÈRES, SUCCESSEURS DE VINCHON,
IMPRIMEURS DES MUSÉES IMPÉRIAUX,
rue J.-J. Rousseau, 8.

A bove: the catalogue of the official Salon of 1864 (above) lists the artists in alphabetical order. Renoir's first presentation is number 1618.

L eft: for all its apparent simplicity, *Arum and Conservatory Plants*, a large-format still life of 1864, is a complete work that reaches much further than a simple 'experiment' in colours. Its similarity to comparable works by Courbet demonstrates its creator's realist tendencies at an early stage.

'I find it relaxing to paint flowers. I don't bring to it the same intellectual tension that I do in the presence of a model. When I paint flowers, I lay down the tones, I boldly try out all the values without worrying about ruining the picture.'
Georges Rivière
Renoir et ses Amis, 1921

Portrait of Mademoiselle Romaine Lacaux of 1864 is one of Renoir's earliest commissioned works. The father of the young girl was a porcelain manufacturer whom Renoir probably knew from the days of his apprenticeship. This painting reveals the young artist's debt to Ingres and Corot, two artists he admired. While honouring the conventions of the genre, Renoir was enough of a master of his medium to express directly the childish freshness of Romaine Lacaux behind the pose of the little bourgeois princess. This sympathy with his young models – conveying both complicity and respect – would show up repeatedly in all his portraits of children, including those of his own.

choices wholesale and only made fun of any new trends. Then, timidly at first, some journalists, art lovers, and dealers rose to the defence of the protesters, suggesting that the supremacy of an art selected for the public's admiration by the reigning powers could and should be called into question.

In this time of flux, Renoir began his artistic career, exhibiting at the official 1864 Salon a canvas entitled *La Esmeralda*, inspired by Victor Hugo's novel *Notre-Dame-de-Paris* (known as The Hunchback of Notre-Dame). (Renoir later claimed to have destroyed the painting.) In the Salon's catalogue, Renoir named Charles Gleyre as his teacher, following tradition, although he had probably left that artist's studio, which was experiencing financial difficulties, during the course of the year. He also stopped attending the Ecole des Beaux-Arts.

The first patrons

In 1865 two of Renoir's works were accepted by the Salon, one of them a portrait of Alfred Sisley's father. However, while the two landscapes Monet was exhibiting drew some critical attention, Renoir received no notice whatsoever. That year, the journalists mainly feasted on the scandal created by Manet's *Olympia*. The show of indifference did not seem to discourage Renoir, for he began work on a large painting, *At the Inn of Mother Anthony*, dated 1866. It portrays his closest

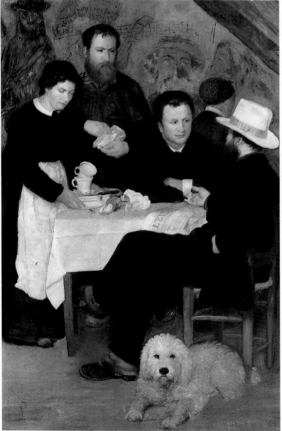

Renoir made use of the same dark palette in both *Portrait of William Sisley* (1864, above), shown at the Salon of 1865, and *At the Inn of Mother Anthony* (left). In the latter, he depicted two of his painter-friends, Jules Le Coeur (standing) and Alfred Sisley (seated on the right). The man with his arms on the table has not been identified.

friends at the time, Sisley and Jules Le Coeur, in an inn at Marlotte, a village on the edge of the forest of Fontainebleau. Here artists and writers used to gather outside Paris.

While Sisley became prominent as one of the original group of Impressionists, the painter Jules Le Coeur is mostly known today as one of Renoir's models as well as his first patron, along with his brother Charles Le Coeur.

The Le Coeurs, a well-off Parisian family, were convinced of the young painter's talent early on and commissioned him to paint portraits, still lifes and even, in 1868, decorations for a town house that Charles had built for Romanian Prince Gheorghe Bibescu.

Marlotte

At the Inn of Mother Anthony was apparently never exhibited at a Salon, yet it figures as a key work in Renoir's early career. This ambitious composition recalls Courbet's large figural canvases. Even if Renoir had not yet had the opportunity to see those works, he had surely heard them discussed. Renoir's painting is a balanced group of realistic portraits in an interior; the subject clearly deals with contemporary life, specifically, the casual, unstudied life of artists. The space is defined simply by the wall of the inn, covered with sketches

Charles Le Coeur, Jules Le Coeur's brother, was one of Renoir's earliest patrons. He appears in the photograph above, flanked by his wife, Marie, and their son Joseph. Renoir sketched Marie and Joseph in a letter to Charles (left) proposing a painting, which was apparently never carried out.

'Ask your wife if she would like me to do her portrait standing and holding Jo by the hand.... You would have to pay for the canvas, seeing that I could not possibly ask Carpentier [an artists' supplier], who would turn me down flat.'

Renoir
Letter to Charles
Le Coeur, c. 1866–8

and scrawls by passing daubers, which functions as a backdrop for the figures.

In this same period Monet placed the figures for his *Déjeuner sur l'Herbe* under the foliage of the forest of Fontainebleau. He had been painting outdoors for some time, under the influence of his mentor Eugène Boudin. In this painting, which is both a homage and a challenge to Manet's painting of the same name, Monet paid special attention to the effects of light.

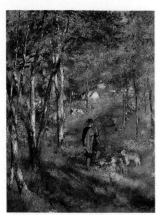

Renoir was not averse to working outdoors. While in Marlotte, he painted his friend Jules strolling with his dogs in the woods. *Jules Le Coeur in the Forest of Fontainebleau* (1866) closely approaches in its spirit and technique the canvases of one of the most famous of the Barbizon painters, Narcisse Diaz de la Peña. Much later, Renoir recalled having come across Diaz at work in the forest of Fontainebleau. He had helped Renoir out by opening an account for him with his supplier so the young artist could buy materials. In any case, this brilliant and fluent artist clearly counted among Renoir's influences.

'Monsieur Renoir, poor fellow, has been rejected'

With this sorrowful statement, Marie Le Coeur, the sister of Jules and Charles, related the young painter's woes in the spring of 1866. She continued: 'On Friday, as no one could tell him if he'd been accepted or rejected, he went to wait for the jury members at the exit to the exhibition, and when he saw Messieurs Corot and Daubigny (two distinguished landscape painters) come out, he asked them if they knew if the paintings of one of his friends, Renoir, had been accepted. Daubigny recalled the painting and described it, telling him: "We are greatly

Jules Le Coeur in the Forest of Fontainebleau (left) is a rare example of Renoir experimenting to learn more about the 'business' of painting. He used a palette knife here, a technique favoured by Courbet.

Opposite below: to be rejected (*refusé*) by the official Salon, depicted by Honoré Daumier in a caricature in 1855, was the worst setback an artist could suffer. Such was undoubtedly the fate of a painting by Renoir that has since been lost; all that remains of the painting itself is a fragment showing the bust of a seated woman, signed and dated 1866. However, a depiction of it exists, thanks to Bazille, who gave it a prominent spot in his *Studio of Bazille, Rue de La Condamine* (1870, detail, opposite above), above his own and Monet's works, thus commemorating the many years they worked together. An X ray of Bazille's canvas reveals that he painted over a study of a female nude in the same pose as Renoir's *Diana*, which was rejected by the Salon of 1867. It cannot be determined if Bazille made the study using the same model as his friend or if he painted over a study by Renoir.

upset on your friend's behalf but his painting
was rejected; we did all we could to prevent it,
we asked for its reconsideration ten times, without
succeeding in getting it accepted, but what could
we do, we were six for it against all the others. Tell
your friend not to be discouraged, that his painting
shows great qualities; he ought to get up a petition
and demand a show of the rejected paintings." So
that, even in his misery, he has the consolation of
receiving compliments from two artists he admires.'

In the end, the jury offered an olive branch by
accepting a small study that Renoir considered only
a sketch, though it did reject the one he deemed
important. Extremely disappointed, he probably
chose not to send anything at all, since

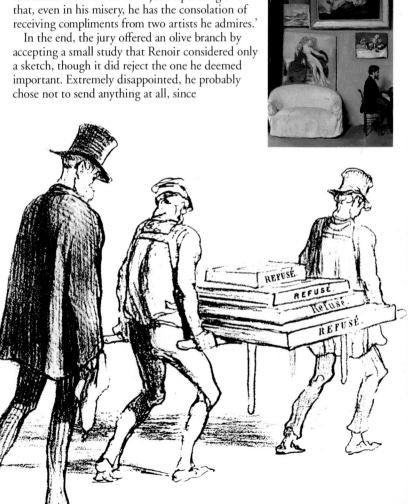

his name does not appear in the Salon's catalogue, while those of his friends Monet, Bazille and Sisley do. Their works were accepted, but Renoir could console himself by saying that Manet, like himself, had been rejected. It is not known whether he followed Daubigny's advice and

wrote to the administration to protest, as Paul Cézanne, one of the year's notorious *refusés*, did. In any case, it is no accident that the newspaper in *At the Inn of Mother Anthony* carries the name *L'Evénement* in capital letters. It was in this daily that Emile Zola, a childhood friend of Cézanne's who was still a budding novelist unknown to the public, published his first pieces of art criticism.

Frédéric Bazille's friendship was of great importance to Renoir. When later asked about his early days, Renoir recalled the memory of his friend, killed at twenty-nine in 1870 during the Franco-Prussian War before he had the chance to fulfil his promise. The wealthy Bazille thought it his duty to help out his friends Monet and Renoir, whom he had met at Gleyre's studio. He admired their talent and shared with them the relative luxury of his studios, the first on the Rue Visconti in 1867 (left), then, from 1868 (with Renoir only), at the Rue de La Condamine. He also bought many of Monet's paintings.

Bazille painted Renoir (opposite above) and Renoir, Bazille (opposite below). The latter work to many minds symbolizes the period in which Impressionism began. On Bazille's easel is the still life *Heron and Jackdaws*, a subject that Sisley had also painted, while a landscape by Monet hangs on the wall. This portrait was owned by Manet, who lent it to the second Impressionist exhibition in 1876.

In these articles, which began appearing in April 1866, he fiercely defended Manet and his friends.

'There is something new at the Rue Visconti'

Frédéric Bazille, who was never short of money, thanks to a regular stipend from his parents, had rented a spacious studio for several months at 20 Rue Visconti when he wrote to his mother at the beginning of 1867, 'Since my last letter there is something new at the Rue Visconti. Monet has fallen from the sky with a collection of magnificent canvases which will be a huge success at the Salon. He will stay here until the end of the month. With Renoir, that makes two needy painters that I'm housing. It's a veritable sanatorium. I'm delighted, I have plenty of space, and both are very good company.' Shortly before this, Bazille had told his father, 'I'm putting up one of my friends, a former student of Gleyre's, who hasn't got a studio at the moment. Renoir – that's his name – works very hard, he uses my models and even gives me something to help cover their expense.'

At this time, Renoir made a portrait of his friend at work, *Bazille Before his Easel*, which dates to 1867. This painting corresponds to a portrait of the same period by Bazille that shows

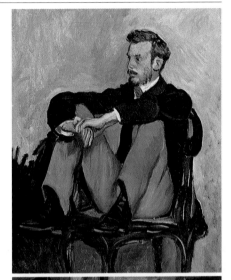

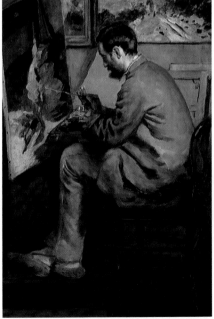

Renoir perched in an unstable position, in sympathy with the nervous and restless temperament that his friends so often described. His thin face, turned away from the viewer, carries an intense expression. His light brown hair is not yet hidden under his later habitual headgear, and he sports the mustache and the short, thin beard that he would retain for the rest of his life.

It was probably in the studio on the Rue Visconti that Renoir painted the Roman goddess Diana the huntress. In *Diana*, he managed to combine novelty, in its kinship with Courbet, and convention, in the choice of subject matter, with an eye to winning the support of the academicians. In this effort he failed. The painting was rejected by the jury of the Salon of 1867, along with works by Monet, Bazille and Sisley. Renoir signed a petition written by Bazille announcing the formation of a new Salon des Refusés, but nothing came of it. This was the year a world fair was held in Paris, and the artists were particularly anxious to place their works before the anticipated large and curious crowd. Weary of seeing his paintings rejected by the jury, Manet, like Courbet, decided to mount a show of them at his own expense; it was located just outside the grounds of the World Fair.

Lise

It was around this time that a young brunette appeared in Renoir's paintings and personal life. Named Lise Tréhot, she was the model for the canvas was entitled *Lise* (1867) that was quite a success at the Salon of 1868. It was caricatured and discussed, despite the fact that it had been consigned, as Jules-Antoine Castagnary, well-known champion of the new painters, put it, 'stowed away, in the rafters next to Bazille's *Family Reunion* and not far from Monet's large *Boats*'. (*Boats* is now lost.) Numerous critics pointed out Renoir's debt to Manet,

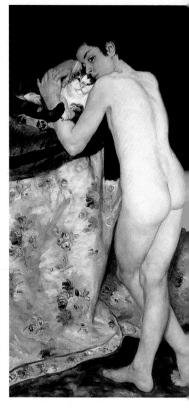

Young Boy with a Cat (1868) remains a mystery. The model is probably a professional who others would have placed in a classical pose. Renoir preferred to capture him in a casual moment as he caresses a cat in front of a piece of luxurious flowered cloth, in keeping with the artist's desire to give his paintings a rich appearance.

Renoir's companion Lise Tréhot (below) posed for a painting exhibited at the Salon of 1868 (left). The caricaturist Gill mocked it, comparing her to

'a semisoft cheese going for a walk' (above). More encouraging commentators said of *Lise*, 'Realist protest, [showing] a great deal of shining talent and promise'.

although one of them also compared the work to a painting by the American Whistler, *Symphony in White, No. 1: The White Girl*, which had created a stir at the Salon des Refusés of 1863.

Emile Zola perceptively demonstrated the close relationship between the works of Renoir and Monet: 'This *Lise* looks to me like the sister of Claude Monet's *Camille* [*Woman in a Green Dress*].... She is one of our wives, or rather, one of our mistresses, painted with great honesty and a successful application of the modern style.'

While the painting did not elicit many other comments, from here on Renoir was inextricably linked with his friends. This is verified by his appearance in two paintings clearly of the new school: *The Studio of Bazille, Rue de La Condamine* by Bazille and *A Studio in the Batignolles* by Henri Fantin-Latour, both of 1870.

Renoir and Bazille remained close friends. They moved to 9 Rue de la Paix aux Batignolles (renamed Rue de La Condamine at the end of 1868) at the beginning of 1868, where Renoir lived until the beginning of 1870.

Exhibited at the Salon of 1866, Monet's *Woman in a Green Dress* (opposite) received much attention in the press. One of the commentators, Zola, was indiscreet enough to point out – as he also did in the case of Renoir's *Lise* – that it was a portrait of the painter's mistress, Camille. What is remarkable is that Zola

Their new neighbour Manet paid them a visit, which served as the pretext for Bazille's painting.

This new studio was close to the well-known Café Guerbois.

Café Guerbois

A group of artists, writers and critics followed Manet, who had begun to frequent the café at 11 Grande Rue des Batignolles (today the Avenue de Clichy). Besides Manet, the most faithful were Emile Zola and the critics

remembered Monet's painting well enough two years later to discern this relationship with Renoir's – proof, if proof were needed, of his familiarity with the painters of the Café Guerbois, shown above in an 1869 drawing by Manet.

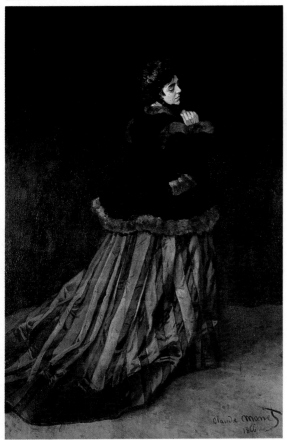

Zacharie Astruc, Edmond Duranty and Théodore Duret. Among the artists, the engravers Marcellin Desboutin and Félix Bracquemond and Bazille, Renoir, Fantin-Latour and Degas came often. When they were in Paris, Cézanne, Monet and Camille Pissarro showed up. Sociable, argumentative, emotional, the group at the Café Guerbois seemed to symbolize the avant-garde just before the Franco-Prussian War of 1870; some malicious critics of the time quickly dubbed it the Batignolles school.

There is no doubt that the model for *Summer* (overleaf right), cautiously subtitled 'study' in the catalogue of the Salon of 1869 to explain its boldly 'unfinished' look, was again Lise Tréhot. Yet the identity of the woman in *Alfred Sisley and his Wife* (also c. 1868, overleaf left) remains uncertain. The man gallantly offering his arm to the young woman in a striped dress is definitely Alfred Sisley. At the time, he was living with a young florist named Eugénie, whom he later married; no portrait of her is known. The young wife in the painted 'couple', however, greatly resembles Lise. Renoir himself alluded in a letter to a work he called *Lise and Sisley*, which could well refer to this painting.

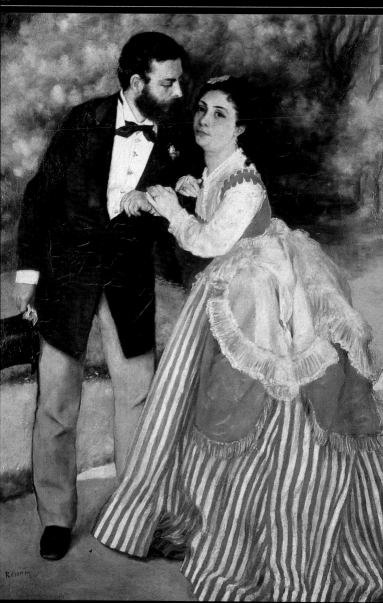

Official success

Lise served as the model for *Summer*, a study exhibited at
the Salon of 1869, and for the two works Renoir showed
at the Salon of 1870 – a *Bather* in the spirit of Courbet
and *Woman of Algiers*, as a homage to Delacroix. These
works display a preference for a firm and fluid style,
a deliberate choice of clearly modern subjects and
a predilection for the figure. The same qualities can be
discerned in the portraits from which Renoir received
the most income, such as *Alfred Sisley and his Wife* and

Renoir painted this
large portrait, *The
Clown,* at the request of
the owner of the café at
the Cirque d'Hiver
(Winter Circus). The
monumental image,
detailed with care, in
contrast to the sketchy
treatment of the
spectators, bears witness
to the fascination of
painters – from Edgar
Degas to Henri de
Toulouse-Lautrec and
Georges Seurat to Pablo
Picasso – with the circus.

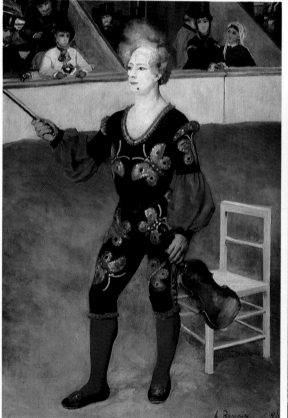

The Clown of 1868. The artist's palette employs lively tones, emphasizing colour contrasts.

Renoir and Monet

The bond between Renoir and Monet grew stronger. In 1869 Renoir saved money by living with his parents in Voisins-Louveciennes, a small town just west of Paris. This placed him near Monet, who was living near Bougival on the Seine. Monet was struggling with constant financial problems, made worse by the birth of a child. Even so, Renoir wrote to Bazille, 'We don't stuff ourselves every day, but all the same I'm happy, because Monet is a good painting companion'. He added with regret, 'I'm doing very little because I have very few paints.' He was undoubtedly thinking of

Woman of Algiers, shown at the Salon of 1870 (with Lise as the model), was mocked by the caricaturist Cham.

these difficult years, which were just beginning, when at the end of his life Renoir told a young friend, the painter Albert André, 'I never had a fighter's temperament and I would have given up many times over had not my good friend Monet, who had it himself – a fighter's temperament – bucked me up'.

La Grenouillère

Renoir and Monet painted together at La Grenouillère, a bathing establishment with restaurant on the Seine at Croissy. The choice of this eminently modern subject suited both artists and shows their nonconformist bent.

'The huge raft covered by a tarpaulin held up by wooden columns was connected to the charming island of Croissy by two gangplanks, one of which led to the centre of the aquatic establishment, while the other… reached the ground next to the office of the baths.'

Guy de Maupassant
La Femme de Paul, 1881

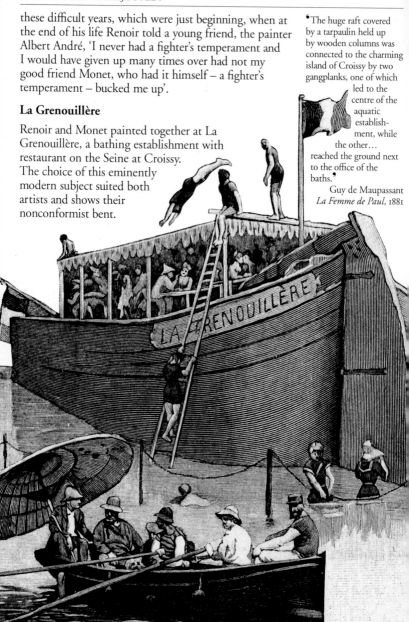

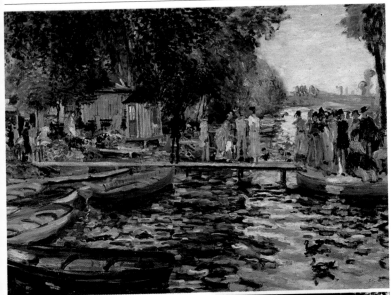

La Grenouillère was a working-class venue, described by some as having a rather louche clientèle. Guy de Maupassant evoked it several years later in *La Femme de Paul* (Paul's Mistress) and *Yvette*. Artists working for the illustrated newspapers often sketched it.

To make it the subject of a painting intended for the Salon – as Monet dreamed of doing, on his own terms – seemed a forlorn hope. For his part, Renoir apparently had no thought of generating a large and important composition from the small ones that he had made on the theme. However, painting outdoors next to a friend and colleague already experienced in the practice doubtless altered his working habits, helped to brighten his palette and enlivened his brushstrokes by breaking them up into smaller units. A point-by-point comparison of the twin canvases of the two painters reveals their differences as well. Monet organized space more structurally, his brushstroke was firmer and his

Guy de Maupassant described perfectly this 'floating café' on the Seine that was called La Grenouillère (a 1902 illustration, opposite). In 1869 Renoir and Monet made twin depictions of the scene (top, Renoir; above, Monet).

format was generally more simplified. Renoir was more expansive with the tip of his brush, the detail of the figures and the play of colours.

In contrast to these canvases bursting with spontaneity, the works that Renoir sent to the 1870 Salon are, as we have seen, much more conservative. They were accepted; Monet's were rejected. The decade thus ended on an encouraging note for Renoir. The serious young man watching Manet at work in *A Studio in the Batignolles* was, according to Fantin-Latour himself, 'a painter who will get himself talked about'.

Taille : 1 mètre *69 c. mil.*

visage *Ovale*

front *ordinaire*

yeux *bruns*

nez *long*

bouche *grande*

menton *rond*

cheveux *ci*

sourcils *blonds*

The war of 1870

In July 1870 war was declared between France and Germany. On 26 August Renoir was drafted into the battalion of the Tenth Cavalry Regiment. Sent to Libourne, near Bordeaux, he escaped the hardships of the siege of Paris but fell ill, the victim of severe depression as well as dysentery. After his discharge he returned to Paris, where he paid little attention to politics and went right back to work. Many changes had occurred in the interim: Bazille was dead, killed in battle; Monet was in England, where he had taken refuge; and Sisley, whose house had been ransacked, found himself in desperate financial straits.

Rejected again

Renoir's first attempt to renew his ties with the official artistic life of Paris met with a rebuff. His large painting *The Harem (Parisian Women Dressed as Algerians)*, an obvious offspring of *Woman of Algiers*, was rejected by the Salon of 1872. This was the last painting for which Lise would pose; in April 1872 she married the architect Georges Brière de l'Isle. A petition that Renoir signed,

Renoir's military record (left) gives a physical description of the young man approaching the age of thirty. While he saw little fighting, he heartily resented the war, as his letters make clear.

'For four months I've been unhappy, feeling deprived of letters from Paris. I've been gripped by utter boredom; can't eat or sleep. Finally I got dysentery as my payoff and I almost died.... Looking at my friends when they came to see me, I realized how far gone I was – they were flabbergasted, they saw me as already dead.'

Renoir
Letter to Charles
Le Coeur,
1 March 1871

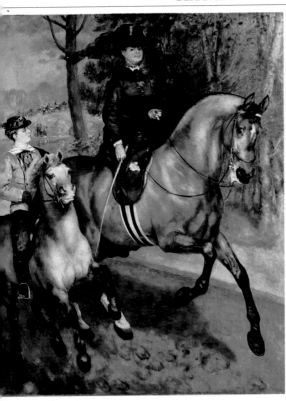

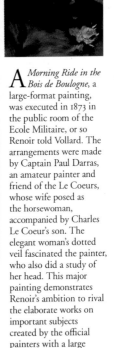

A *Morning Ride in the Bois de Boulogne*, a large-format painting, was executed in 1873 in the public room of the Ecole Militaire, or so Renoir told Vollard. The arrangements were made by Captain Paul Darras, an amateur painter and friend of the Le Coeurs, whose wife posed as the horsewoman, accompanied by Charles Le Coeur's son. The elegant woman's dotted veil fascinated the painter, who also did a study of her head. This major painting demonstrates Renoir's ambition to rival the elaborate works on important subjects created by the official painters with a large realist composition in the style of Courbet – which probably explains why the jury rejected it. This is the last painting with ties to the Le Coeur family, with whom he quarrelled for reasons which remain obscure.

along with such artists as Manet, Fantin-Latour, Pissarro and Cézanne, asking for the creation of a Salon des Refusés, went unanswered. He suffered another rejection the following year with an unidentified portrait and a very large painting entitled *A Morning Ride in the Bois de Boulogne* depicting Mme Henriette Darras, a friend of the Le Coeurs, on a horse, accompanied by Charles Le Coeur's son Joseph on a pony.

These works were displayed at the Salon des Refusés of 1873 in a defiant gesture that showed that Renoir was distancing himself from the official art world. Convinced that the jury was deliberately excluding him, he decided he would never again send another painting to the Salon.

Renoir is above all a painter of people. The dominant feature of his work lies in his range of tones and the way in which they are combined in a wonderful harmony. You feel that you are seeing Rubens illuminated by the fiery sun of Velázquez.'

Emile Zola
'Deux Expositions d'Art en Mai'
Le Messager de l'Europe
Saint Petersburg, June 1876

CHAPTER 2

RENOIR, IMPRESSIONIST

The novelist Zola was remembering Renoir's *The Swing* (1876) when describing his heroine of *Une Page d'Amour* (1878): 'Standing on the plank, her arms opened wide holding on to the ropes…she wore a grey dress decorated with light purple bows.' Meanwhile, her daughter was entranced by 'round spots, of a lovely golden yellow, that danced on her shawl. It was easy to imagine them as creatures'.

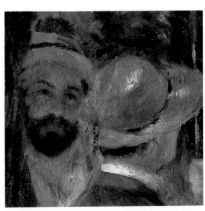

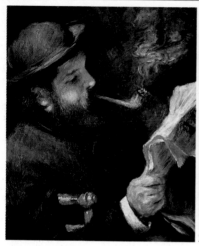
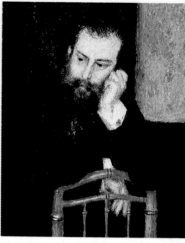

With Claude Monet at Argenteuil

When Monet moved to Argenteuil (just north of Paris) at the end of 1871, after a trip to Holland that followed his voluntary exile in England during the war in 1870, Renoir made frequent visits to see him. The portraits Renoir made of his friend and his wife, Camille, provide the most visible proof of these visits, although there are also the many paintings by the two artists that share a subject, such as *The Seine at Argenteuil*. Here, as elsewhere, the influence of Monet seems to have been predominant, if only because Monet induced his friend to set up his easel in the open air again, as he had at La Grenouillère.

Monet had many other visitors at Argenteuil: Pissarro, Sisley, who remained one of Renoir's closest friends and, somewhat later, Manet, who had no hesitation about learning from his

Claude Monet (above left) and Alfred Sisley (above right) remained Renoir's familiar models and close friends over the years. At Argenteuil Monet often painted racing sailing boats, which led Renoir to try his hand at the same theme (*The Seine at Argenteuil*, 1874, below).

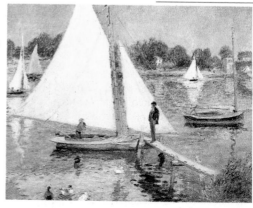

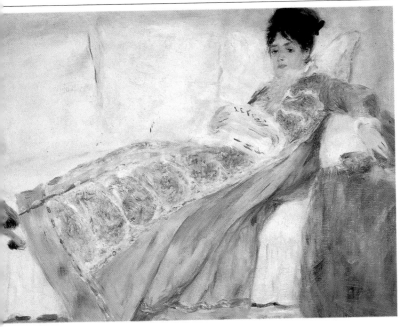

young friends, all came to see him. The group had never been more tightly bound together.

1874: the first Impressionist exhibition

The artists' conversations often centred on the Salon. These *refusés*, or rejected, felt compelled to organize exhibitions of their works in order to survive. They realized there was no point in endlessly petitioning the administration for a 'Salon des Refusés'. It was up to the artists themselves to take the initiative, which would give them control over who would be shown with them. This was not a new idea; in his letters to his parents, Bazille had alluded several times since 1867 to projects for artists' associations, all of which were abandoned due to lack of funds.

On the other hand, the Société Anonyme, a cooperative of painters, sculptors, engravers and other artists, founded on 27 December 1873 with Renoir a member, succeeded in mounting its first exhibition in the spring of 1874 in

Renoir made numerous portraits of Claude Monet's wife, Camille, around 1872. One of the best shows her reading a newspaper, stretched out among the fat cushions of a sofa (above). In this small canvas, painted at one sitting, Renoir demonstrated his facility for depicting shimmering textiles with an astonishing economy of means. At the same time he succeeds in maintaining the composition's mood of gracious and spontaneous intimacy, punctuated by the pretty black of the young woman's two small feet.

41. *Danseuse.*		*3000*
42. *L'avant-scène*		*2500*
43. *Parisienne.*		*3500*
44. *Moissonneurs.*		*1000* *vendu par le traité à Mme Hartmann.*
45. *Fleurs.*		
46. *Croquis* (Pastel).	*n'a pas été envoyé à l'Exposition*	

The annotations in a catalogue of the first Impressionist exhibition (1874, left) reveal the identity of one of the first buyers, the music publisher Hartmann, and the relatively high prices that Renoir set, especially for his large painting *The Parisienne* (1874, below). He later sold this painting to Henri Rouart, one of Degas' friends.

Paris. Held in a space rented for the occasion at 35 Boulevard des Capucines, the exhibition included the work of Degas, Pissarro, Sisley, Berthe Morisot, Cézanne and Armand Guillaumin, as well as Renoir and Monet. Manet decided to show at the Salon instead.

Making fun of the group, one critic, Louis Leroy, coined the term 'impressionist', playing on the title of a painting shown by Monet, *Impression, Sunrise.* The name stuck.

Critical reaction in 1874

Renoir was represented in the exhibition by an important selection of recent canvases that he put before the public for the first time: *The Dancer, La Loge (The Box). The Parisienne, Harvesters* and two unidentified works called *Flowers* and *Head of a Woman*. It could be said that Renoir was remaining true to his old themes, giving pride of place to the 'modern figure'.

One critic, Jean Prouvaire, saw in the three female subjects of *The Dancer, La Loge* and *The Parisienne* 'the three stages through which all young ladies of Paris pass', from the adolescent to the 'flirt', which indicates that Renoir's contemporaries looked on his work as genre painting.

The critics treated Renoir much more gently than his friends, concentrating more on subject matter than on style. Favourable reviews came from friendly journalists: 'M. Renoir is daring,' said Castagnary. 'M. Renoir has a great future.... He delights in his rainbow

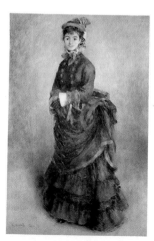

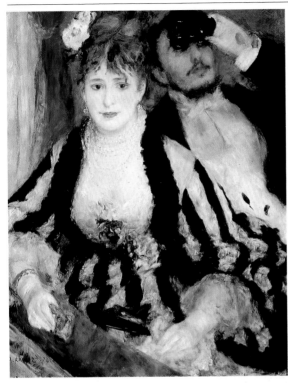

Tradition insists that the models for *La Loge (The Box)* of 1874 were Edmond Renoir, journalist and brother of the artist, and Nini, a model whose nickname Gueule-de-Raie ('Fish Mouth') contrasts cruelly with the elegance of her Watteau-like finery. Contemporary critics were quick to label the woman as a 'cocotte', one of those women with 'cheeks powdered to a pearl-like sheen, their eyes lit by a banal passion …engaging, empty, delightful and stupid'.

The photographer Nadar had already moved out of his studio at 35 Boulevard des Capucines (below) by the time Renoir and his friends held the first exhibition of their group there in 1874.

effects, his light, pearly tones like Turner's. However, his drawing is much more solid,' asserted Philippe Burty. While the exhibition did not pass unnoticed, it was not a commercial success, though some works were sold.

Impressionism at auction

The group did not organize an exhibition in 1875, the Société Anonyme having been dissolved due to its large debts. To raise money, Renoir, Monet, Sisley and Berthe Morisot delivered several works to the auction house at the Hôtel Drouot in Paris on 24 March 1875.

The viewing of the pieces was turbulent –
the crowd openly jeered the artists of the group
– and the financial results proved disastrous for
Renoir: little more than 2000 francs for twenty
canvases, two of which the artist bought back.

This is clearly a negligible sum when seen in
comparison with the fact that the government,
parsimonious as it was, rarely paid less than
3000 francs for a painting bought from the
Salon, and a painting by Jean-Louis-Ernest
Meissonier (known for his high prices) could
fetch as much as 200,000 francs.

Among the buyers were two artists who
had exhibited with the group in 1874, the Swiss
Auguste de Molins and Henri Rouart, a friend
of Degas who was also a distinguished collector;
two author-critics, Arsène Houssaye, publisher
of the prestigious periodical *L'Artiste*, which was
popular in the worldly and literary circles of Paris,
and Emile Blémont; Monet's brother Léon; Morisot's
cousin Gabriel Thomas, who later became a promoter

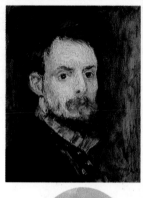

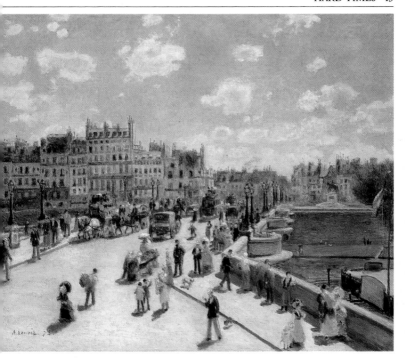

for the Eiffel Tower and for Auguste Perret's Théâtre des Champs-Elysées; manufacturer Jean Dollfus; and publisher Georges Charpentier, who would become one of Renoir's strongest supporters.

The artists' disappointment was equalled only by that of the auction's expert, the Parisian dealer Paul Durand-Ruel. He did what he could to keep the prices up, including bidding for – and succeeding in buying – several paintings himself.

Durand-Ruel

Soon after the war of 1870, Durand-Ruel had bought paintings from Manet, Monet and Pissarro, whom he knew from London during the war, and from Degas, Sisley and finally Renoir. His first Renoir was probably *The Pont des Arts, Paris*, acquired on 16 March 1872 for 200 francs.

A photograph and a self-portrait (opposite centre and above) show the artist around 1875. His thin, drawn face seems to reflect his financial difficulties. For example, *The Pont Neuf, Paris* (1872, above) drew a bid of only 300 francs at the Hôtel Drouot, the Paris auction house (illustrated opposite below), where the Impressionists, having lost money in their first exhibition, organized a sale of their works in the spring of 1875.

Durand-Ruel was the son of a dealer who had supported Delacroix and the school of 1830, Théodore Rousseau and the painters of the Barbizon school before they became commercially successful. He grasped the mechanisms of the nascent art market very early and knew the value for the dealer of 'discovering' new talents before anyone else.

At the beginning of the 1860s, Durand-Ruel was practically the only one to champion Manet and his friends, as he had Courbet before them. It would be several years before he began buying Renoir's works in quantity, but the two men stood by each other throughout their relationship, in good times and bad.

Marcellin Desboutin portrayed Paul Durand-Ruel in 1882 (left). Renoir's *Mother and Children* (1874, opposite) and *Nude in Sunlight* (1875, bottom).

LE PEINTRE IMPRESSIONNISTE.
— Madame, pour votre portrait il ma quelques tons sur votre figure. Ne pou vous avant passer quelques jours au fond rivière?

1876: the second Impressionist exhibition

According to Théodore Duret and Edmond Maître, two of his friends, Renoir was considering sending in 1875 to the official Salon works that had been rejected the previous year, but no confirmation of this exists. In any case, Renoir again allied himself with the Impressionists when in April 1876 they repeated the experiment of an independent exhibition.

It had become all the rage for the critics to deride them. Although he came in for slightly less chaff than his fellows – including Degas, Monet, Morisot, Pissarro, Sisley and a newcomer, Gustave Caillebotte, who were accused of creating works 'that would make a cab horse panic'

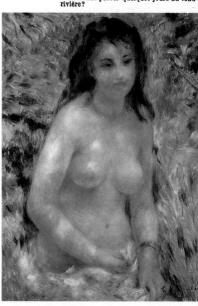

– Renoir was still a target for their sarcasm. Arthur Baignières wrote of his 1874 *Mother and Children*, 'From afar we see a bluish haze, from which six chocolate drops forcefully emerge. Whatever could it be? We come closer; the sweets are the eyes of three people and the haze a mother and her daughters.' This comment is characteristic of the overall objection to the Impressionists: that they offered to the public ridiculous unfinished paintings that lacked drawing skills.

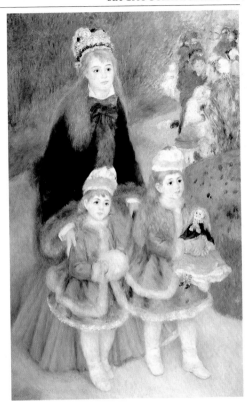

Some patrons in 1876

For the first time, the exhibition catalogue mentioned the owners of some of the exhibited works, which indicates that the Impressionists continued to attract attention without benefit of the official Salon. Unfortunately, the supporters were precious few in number. Those who championed Renoir were Manet, Victor Chocquet, Jean Dollfus, Alphonse Legrand and Victor Poupin.

Manet, who was rather more than simply a patron, had nonetheless discreetly purchased from time to time a canvas from one of his young friends in financial straits. He lent to the show the 1867 portrait of Frédéric Bazille in memory of a comrade who had died young. It was on this occasion that he swapped his painting with one owned by Bazille's father, who wanted to possess this memento of his son killed in battle; Manet received a Monet in exchange.

One critic described *Nude in Sunlight* (opposite) as 'a mass of decomposing flesh with green and purplish spots, indicating the state of total putrefaction in a corpse', an idea cartoonists took up with glee. The caption to the cartoon reads, 'Madame, your face lacks certain flesh tones I need for your portrait. Could you not return after spending several days at the bottom of a river?'

Victor Chocquet was a minor civil servant in the Ministry of Finance who used his small means to buy paintings. He was known to have greatly admired Delacroix, and he discovered Renoir at the sale of 1875, although he did not buy anything then. His other infatuation, which Renoir encouraged, was for Cézanne; at the time, Chocquet was almost his only patron. Emile Zola later modelled Monsieur Hue in the novel *L'Oeuvre* on Chocquet; the character was described as a 'former department head' who collected the works of Delacroix and the painter 'Claude Lantier', alias Manet, Monet, Cézanne.

Jean Dollfus came from an entirely different world, the textile and industrial dynasty Dollfus Mieg, and enjoyed a substantial income. This connoisseur of old masters, Corot, Delacroix (Renoir copied Delacroix's *Jewish Wedding in Morocco* for him at the Louvre), and Far Eastern art owned only a few pieces by Renoir. Unusual for his time, Dollfus frequently attended sales at the Hôtel Drouot and daringly bid for, and bought, a Renoir painting at the sale of 1875. He kept it to the end of his life.

Alphonse Legrand, who lent a portrait of his daughter Delphine, and Victor Poupin were two dealers connected with Durand-Ruel, whose gallery at 11 Rue Le Peletier housed the exhibition.

Two names will complete this modest list. The first, Georges de Bellio, a 'Romanian gentleman' and homeopathic physician, would retain a lifelong connection with Renoir. In 1876 he bought his first Renoir from

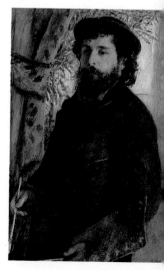

Durand-Ruel; his claim to fame is the purchase, in 1878, of Monet's notorious *Impression, Sunrise*, the centre of a collection that constituted the first group of Impressionist paintings of the Musée Marmottan in Paris (bequeathed by his daughter).

Gustave Caillebotte, Impressionist and patron

Although his name appeared as an artist rather than a patron, it is appropriate to introduce Gustave Caillebotte on the occasion of the exhibition of 1876.

He was a rich young man who painted. His *Floor Scrapers* was rejected by the Salon of 1875, and in

On 23 June 1876 Renoir signed a receipt for the modest sum of 300 francs (opposite above) Jean Dollfus paid for two paintings. One was *Head of a Woman*, the other *Portrait of Claude Monet* (1875, opposite below), some of whose works the collector also owned. Dollfus lent both of the Renoirs to the exhibition of the Impressionist group in 1876.

According to Albert André, Renoir and a friend were going round an exhibition and, in front of his *Portrait of*

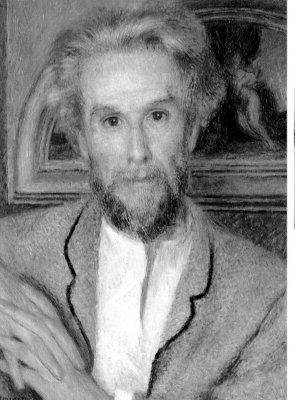

Victor Chocquet (1875, left), the painter commented, 'Portrait of a nut...by a nut.... What a charming crackpot! He didn't have his fortune at that time and he scraped up the means to buy paintings from his salary at the ministry and never gave a thought to whether or not the art would appreciate in value.'

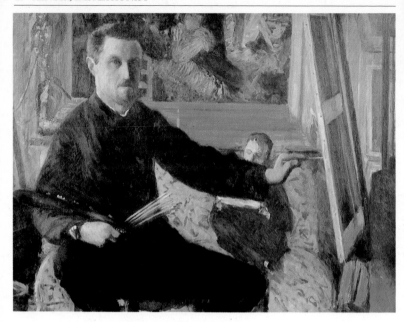

February 1876 he accepted the invitation by Renoir and Rouart to show with their group.

He began to buy pieces by his Impressionist colleagues. On 3 November 1876, deeply affected by the death of his older brother René, Gustave Caillebotte wrote a will at the age of twenty-eight that directed that a considerable sum of money be allocated to organize an exhibition of the 'painters called the Intransigents or the Impressionists' in 1878. He already envisaged leaving to the State his collection of paintings, naming Renoir and his brother Martial Caillebotte as executors.

He was destined to be alive and well in 1877, and able to contribute not only extravagant sums of money but also his own works as well as his talents as organizer and conciliator. Symbolically, Caillebotte took over the role Bazille had filled among his friends. Suffice it to say that the circle of Renoir's supporters remained small but was not lacking in enthusiasm.

Despite the second exhibition's poor showing, Renoir went right back to work, undertaking

To paint himself in about 1879, Gustave Caillebotte (above) used a mirror that also reflected a painting hung on the wall of his studio, which he accordingly painted in reverse. It is *Dancing at the Moulin de la Galette*, by his friend Renoir. He probably purchased it soon after the exhibition of 1877, or so an 1879 article in *L'Artiste* implied: 'This charming painting …one of Renoir's best works, was bought by M. Caillebotte, who had no desire to trade it for the *Vénus* by Bouguereau', a fashionable painter of the time and the Impressionists' bête noire.

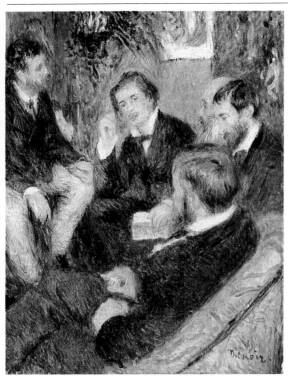

The Artist's Studio, Rue Saint-Georges (1876–7, left), a small canvas painted in about 1876 with nervous and rapid strokes, shows Renoir's studio and friends, from left to right, painter Pierre Franc-Lamy; Georges Rivière, the artist's biographer; Camille Pissarro, the doyen of the Impressionists (his profile can just be made out); and musician François Cabaner, one of the most striking personalities of that intellectual bohemian circle. Before he died in poverty at the age of forty-eight in 1881, he had been linked with Manet and Cézanne; he invented a system of 'coloured hearing', and he dedicated his *Sonnet des Sept Nombres* to poet Arthur Rimbaud. The figure seen from the back in the foreground is Pierre-Eugène Lestringuez, a civil servant and friend of the composer Emmanuel Chabrier. According to the memoirs of Jean Renoir, the painter's filmmaker son, he was also a devotee of the occult sciences. Franc-Lamy, Rivière and Lestringuez also posed for *Dancing at the Moulin de la Galette*.

his most ambitious composition of the decade, *Dancing at the Moulin de la Galette*.

Dancing in Montmartre

While continuing to live at 35 Rue Saint-Georges, where he had moved in 1873 and which remained his address for nearly ten years, Renoir rented a studio on the Rue Cortot in Montmartre, which was then still a suburb of the city, dotted with gardens and windmills. Several paintings evoke the garden of the Rue Cortot studio, notably *The Swing*. On the other hand, *Dancing at the Moulin de la Galette* (1876) was painted largely on the site of the pleasure garden of the same name. Today, nothing remains of the establishment but traces of the windmill; the bright green buildings and

the garden where people danced beneath the stunted trees had vanished by the turn of the century.

Georges Rivière, friend and biographer of the artist, emphasized that the painting had been executed 'entirely on the spot', a masterpiece of plein-air painting. However, it should be noted that many sketches of both details and the whole composition do exist.

His choice of this popular dancing spot took Renoir back to a theme he had first attempted in 1869 at La Grenouillère, but the large format reveals his greater ambitions. Both subjects involved representing a crowd in movement and incorporating the complex patterns of light filtered through the foliage.

In this new painting he also made the foreground figures as detailed as portraits. The composition could function as a naturalistic document, as Rivière also pointed out, 'a page out of history, a precious monument of Parisian life, of a rigorous realism' in the classical tradition of a renewed historical painting. However, he went on, 'What distinguishes the Impressionists from other painters is that they treat the subject for its tonal value, not its content'.

Renoir was clearly working out a series of experiments that began with much smaller works, especially in the use of a fluid, allusive technique that models forms through colour, without depending on outlines; even the shadows are coloured.

This aspect of his work was attacked by the critics of the Impressionists. They were startled to see, for example, 'people dancing on a floor that looks like the purplish blue clouds darkening the sky on a stormy day' and defying all the known laws of perspective, while his friends saw 'the brilliant reflections of a rainbow'.

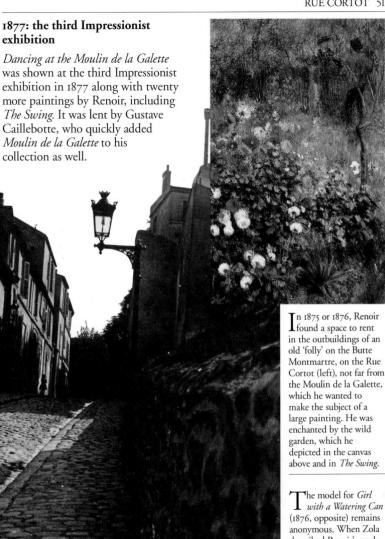

1877: the third Impressionist exhibition

Dancing at the Moulin de la Galette was shown at the third Impressionist exhibition in 1877 along with twenty more paintings by Renoir, including *The Swing*. It was lent by Gustave Caillebotte, who quickly added *Moulin de la Galette* to his collection as well.

In 1875 or 1876, Renoir found a space to rent in the outbuildings of an old 'folly' on the Butte Montmartre, on the Rue Cortot (left), not far from the Moulin de la Galette, which he wanted to make the subject of a large painting. He was enchanted by the wild garden, which he depicted in the canvas above and in *The Swing*.

The model for *Girl with a Watering Can* (1876, opposite) remains anonymous. When Zola described Renoir's work as 'Rubens illuminated by the fiery sun of Velázquez', he was undoubtedly thinking of paintings such as this.

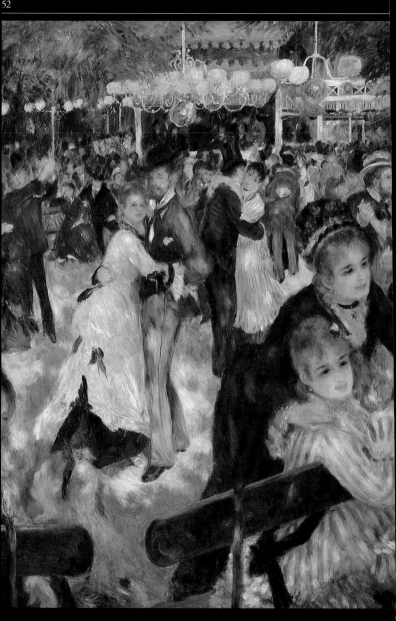

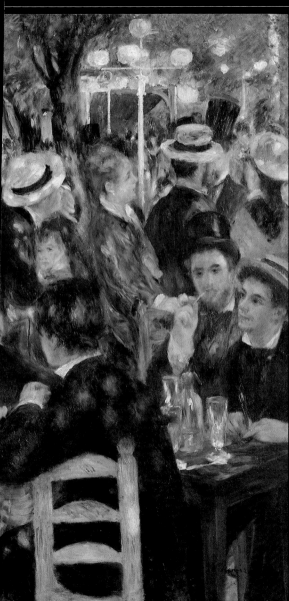

In *Dancing at the Moulin de la Galette* Renoir used not professional models but friends and some working-class women from Montmartre – Jeanne, Estelle, Margot – who were regulars there. Georges Rivière, depicted at the table on the right with the painters Norbert Goeneutte and Franc-Lamy, listed the others: the painters Gervex, Frédéric Cordey, and a Cuban, Pedro Vidal de Solares y Cardenas, whose painting has nothing in common with Renoir's, and Renoir's friends Lestringuez and Paul Lhôte, a journalist and aspiring novelist. Lhôte clearly made a tractable model, as he reappeared several years later in the series of *Dances*.

Other much-discussed works, since they involved well-known personalities of the day, were portraits of Eugène Spuller, a republican deputy and friend of the statesman Léon Gambetta, and the actress Jeanne Samary. Similarly, portraits of the wives of writer Alphonse Daudet and publisher Georges Charpentier were recognized. Charpentier already owned several canvases by Renoir and was on his way to becoming a full-fledged patron. His support continued to grow. Indeed, Charpentier

CATALOGUE
DE LA 3e

EXPOSITION
DE PEINTURE

PAR MM.

CAILLEBOTTE — CALS — CÉZANNE — CORDEY
DEGAS — GUILLAUMIN — JACQUES-FRANÇOIS — LAMY
LEVERT — MALTEAU — C. MONET — B. MORISOT
PIETTE — PISSARRO — RENOIR — ROUART
SISLEY — TILLOT

6, RUE LE PELETIER, 6
PARIS

AVRIL 1877

In 1877, the third exhibition of the Impressionist group, like all the others, produced a catalogue (above). Unfortunately, it did not include any reproductions, which has made the identification of the works shown very difficult, the evidence consisting only of descriptions made by critics and the rare confirmation of eyewitnesses.

Jeanne Durand-Ruel, first painted by Renoir in 1876 (left), was one of the five children of Paul Durand-Ruel, Renoir's dealer.

would have a greater impact on Renoir than the Le Coeurs, with whom Renoir fell out before 1875.

At the time of the 1877 exhibition, Renoir suggested to Georges Rivière that he publish a periodical called *L'Impressionniste*. Four issues came out in April. The issue of 14 April included a letter from Renoir signed 'A painter', and the issue of 28 April carried an article he wrote that was called 'Decorative and Contemporary Art'.

In the latter, he set out his deeply felt ideas concerning the interdependence of the arts and the decadence of the modern period, victim of mechanization, that he held throughout his life. Unfortunately, the periodical never spread beyond the circle of its originators, so it hardly helped in the effort to enlist serious patrons.

In search of new patrons

Another public auction of the works of Renoir, Caillebotte, Pissarro and Sisley, among others, was held at the Hôtel Drouot on 24 May 1877, and it proved just as disastrous as the first. Fortunately, Renoir had enough portrait commissions to get by. Several of these commissions came from an eccentric character who nevertheless has earned himself a place among the pantheon of the earliest Impressionist patrons.

Under the pseudonym of Eugène Murer, Eugène Meunier wrote many eminently forgettable literary works. The real vocation of this self-taught man was running a small but prosperous pâtisserie in Paris. One of his childhood friends, Armand Guillaumin, had introduced

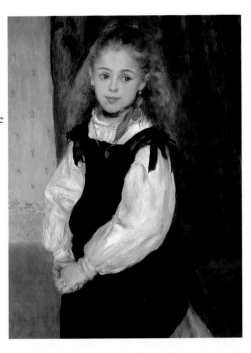

Portrait of Delphine Legrand (1875, below) was shown at the second Impressionist exhibition in 1876. Her father, an art dealer, did business with Durand-Ruel, but his association with the Impressionists proved a commercial disaster. He paid for the rental of the exhibition rooms on the Rue Le Peletier in 1876, served as valuer for the 1877 sale, and with Caillebotte tried unsuccessfully to organize a new exhibition of the group in 1878.

him to Cézanne, Pissarro, Sisley, Renoir
and Monet. He bought paintings from
all of them (although at low prices, since
times were hard and the painters willing
to make sacrifices), invited them to dinner,
organized local raffles with a painting by
Pissarro as first prize.

From Renoir, whom he preferred and
who responded to him with the greatest
warmth, he bought as many as thirty
paintings, including such important
works as *The Arbour (Sous la Tonnelle)*
(about 1876). The collection was
subsequently scattered during the
collector's lifetime.

One of Murer's relatives was an old
friend of Pissarro's and Cézanne's, Dr Paul
Gachet, who practised in Paris. At the
beginning of 1879, Renoir appealed to Dr
Gachet and Georges de Bellio to save Anna Leboeuf,
a seriously ill young woman who had modelled for him
and perhaps played a role in his personal life as well.
The doctors could do nothing for her, and
she died. As a memento, Renoir
offered Dr Gachet a portrait of
another young woman, which
joined a collection (later
bequeathed by his son to
the French national museums)
that included many works
by Cézanne, Pissarro and
Guillaumin. (It was also to Dr
Gachet that Vincent van Gogh
turned after his discharge from the asylum
in May 1890. Dr Gachet could not help
him either; Van Gogh killed himself. The image
of the doctor-friend of artists painted by
Van Gogh, however, passed to posterity.)

Another of Renoir's patrons of
the period is famous in his own right:
the composer Emmanuel Chabrier.
A friend of Manet's and, especially,

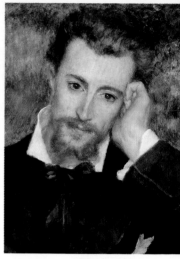

Eugène Murer was
painted by numerous
artists, notably Pissarro
and, in 1877, Renoir
(above). His friend Dr
Paul Gachet was drawn
by Charles-Lucien
Léandre (below).

Monet's, he was introduced to Renoir by his colleague Pierre-Eugène Lestringuez, who also worked at the Ministry of the Interior and who had posed for Renoir's *Dancing at the Moulin de la Galette*. He bought several important works from Renoir to augment his collection of Impressionist paintings, which, unfortunately, was dispersed after his death.

1878: 'the Impressionist painters'

Among the small group of critics favourably disposed towards the Impressionists, one of the most fervent supporters of Renoir was undoubtedly Théodore Duret. A zealous republican who had renounced a political career, he lived off the income from the family cognac business. Closely tied to Emile

When the composer Emmanuel Chabrier (humorously depicted at the piano by the very serious military painter Edouard Detaille, below left) bought Renoir's *Nude* (1876, below), traditionally known as *Anna*, who was the presumed model, he was taken aback by his wife's reaction to its frank sensuality. She accepted it, though, as she accepted her husband's passion for the most controversial painting of the time, that of Manet, Monet, Sisley and Cézanne. In many respects, Chabrier's music, which was slow to be

appreciated, held a position comparable to that of Impressionism in its time.

Zola, he also became a critic and a friend of Manet's.

He bought his first Renoir painting in 1873, on his return from a trip around the world that took him and the financier Henri Cernuschi to Japan. *Summer* had been shown at the Salon of 1869. This purchase made Duret one of Renoir's earliest supporters. He wrote a pamphlet that is now a significant document in the history of the movement, *Les Peintres Impressionnistes* of 1878, and he chose a drawing by Renoir to illustrate it. The drawing was done after the painting *Lise*, which Duret owned.

Théodore Duret was portrayed by Manet, Whistler and Edouard Vuillard – which in itself demonstrates the breadth of his artistic relationships. He may be the only critic – of those who had been among the first to support Manet and the Impressionist painters (witness the frontispiece of his 1878 brochure with a reproduction of Renoir's *Lise*) – who also recognized the genius of Cézanne, Van Gogh, Gauguin and Toulouse-Lautrec.

THÉODORE DURET

LES

PEINTRES

IMPRESSIONNISTES

CLAUDE MONET — SISLEY — C. PISSARRO
RENOIR — BERTHE MORISOT

AVEC UN DESSIN DE RENOIR

PARIS
LIBRAIRIE PARISIENNE
H. HEYMANN & J. PÉROIS
35, AVENUE DE L'OPÉRA, 35

Mai 1878

Renoir himself was not particularly happy to be classed among the 'Impressionists' or 'Intransigents': 'I never wanted to play the martyr, and if my paintings had not been rejected by the Salon I would certainly have continued sending them…. I have always believed, and continue to believe, that I am only doing what others have done before me and done much better,' he later said.

In 1878, encouraged by Duret and his new patrons, notably the Charpentiers, he returned to the Salon, again modestly labelling himself a student of Gleyre, with the painting *The Café*.

He sent four portraits to the Salon in 1879 and, like Cézanne, Morisot and Sisley, contributed nothing to the fourth Impressionist exhibition, as no one who had

Referring to the works by Renoir in his possession, Duret wrote in 1878, 'I doubt that any other painter has ever interpreted women in as seductive a manner. Renoir's light and rapid brush lends them grace, suppleness, ease, renders their skin transparent, colours cheeks and lips with a rosy glow. Renoir's women are enchantresses.' Happily for other artists, Duret's literary enthusiasm translated into purchases of their works as well, although at friendly prices (or even paid in cognac, the source of the family fortune), and Renoir, like the others, knew where to write when the need arose, as illustrated by the envelope reproduced opposite.

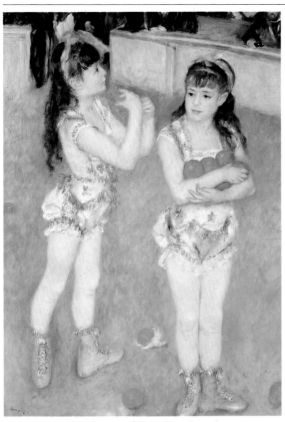

Curiously, a little more than a decade after portraying *The Clown*, Renoir painted another circus scene (*Two Little Circus Girls*, 1879, left) using a similar composition. While it was not listed in the catalogue, it was shown at the seventh Impressionist exhibition. Angelina and Francisca Wartenberg, the two young jugglers pictured here, performed at the Cirque Fernando on the Boulevard Rochechouart in Paris, not far from Renoir's studio. The same circus (which became the Cirque Medrano before it vanished) inspired Degas' *Mlle La La at the Cirque Fernando*, Seurat's *The Circus* and Toulouse-Lautrec's *Cirque Fernando* and *At the Circus*, amongst others.

paintings at the Salon was allowed to show there. This strategy brought him luck and marked the beginning of a new phase in the artist's career.

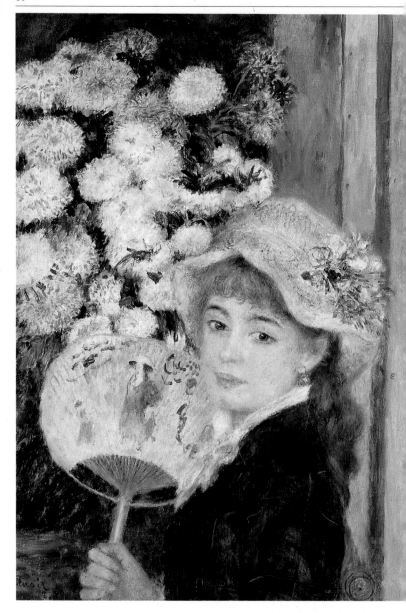

R enoir has had a great success at the Salon. I think he's made, thank goodness. Poverty is hard!'

Camille Pissarro
Letter to Eugène Murer
27 May 1879

CHAPTER 3

SUCCESS AND MATURITY

Of all the Impressionists, Renoir was the least affected by the craze for things Japanese that so strongly marked this generation of artists. Nevertheless, by placing a cheap Japanese fan in the hands of his young model (probably the actress Jeanne Samary) in 1881, for once he gave in to the fashion, painting a 'Japanese Parisian'.

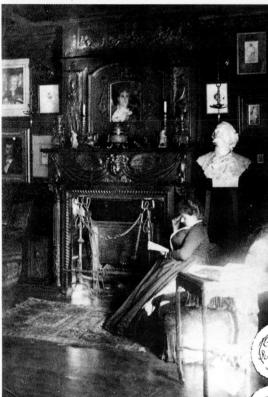

Around 1876 or 1877 Renoir made his first *Portrait of Madame Georges Charpentier* (above), which she placed on the mantelpiece in her drawing room (left). For one of her many dinner parties, which brought together the cream of Paris's intellectual, political and artistic elite, Renoir draw a menu (below).

'The most devoted of painters-in-waiting'

Renoir owed his success at the Salon of 1879 chiefly to one person, Mme Charpentier, whose portrait he showed there. Marguerite Charpentier was married to Georges Charpentier, publisher of Flaubert, Daudet, Zola, the Goncourt brothers, Maupassant and Huysmans. She was the offspring of a solid bourgeois family, her father having been jeweller to the imperial court before he was ruined in the fall of the Second Empire.

In her dwelling on the Rue de Grenelle, Mme Charpentier held a salon of a decidedly republican

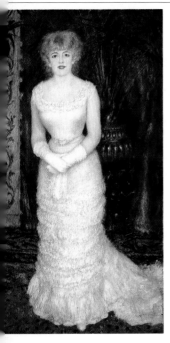

cast. However, its main theme was literary, as it united all the authors that her husband published. While it was a gathering in the best of taste, it was not stuffy, and its habitués found it entertaining. It brought together actresses of the moment, like Jeanne Samary, as well as personalities like Yvette Guilbert, a café-concert singer immortalized by Degas and Toulouse-Lautrec, or the composer Jules Massenet. Numerous artists were welcomed, ranging from Jean-Jacques Henner, whom no one could accuse of avant-garde tendencies, to Manet, a great admirer of Isabelle, the sister of the hostess, and Monet, Sisley and, especially, Renoir, who became the 'painter-in-waiting' to the Charpentiers.

Both of the Charpentiers contributed to spreading the renown of their protégé, in different ways. Georges first bought paintings by Renoir at the Impressionist auction of 1875 and soon gave him various commissions for portraits and decorations, paying in advance with no hesitation, just as he had with Monet and Sisley. Marguerite used all the advantages of her salon to benefit Renoir. In return, Renoir painted several portraits of her – the first of which had been exhibited in 1876 (it is now in the Musée d'Orsay in Paris) – and her children, Georgette, born in 1872, and Paul, born in 1875. The large work *Portrait of Madame Charpentier and her Children*, shown at the Salon of 1879, brought Renoir fame.

Marguerite Charpentier was a strong personality. Not content merely to give dinner parties for her publisher husband's authors or well-known republican politicians, she invited such artists, actors and popular singers as Yvette Guilbert and later Aristide Bruant (whose vocabulary shocked author Edmond de Goncourt, a regular). At her salon, Renoir met the young actress Jeanne Samary, whose career was just beginning to take off. The large standing portrait he made of her in 1878 (left) – which followed a small bust portrait, as he had done with Mme Charpentier – contributed to Renoir's success at the official Salon of 1879. The many people Mme Charpentier introduced to Renoir resulted in numerous portrait commissions, which finally gave the painter a measure of financial security. They also presented this son of a tailor with the opportunity to create a network of relationships that would have an important impact on his career.

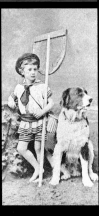

The large *Portrait of Madame Charpentier and her Children* (1878, left), which created a stir at the Salon of 1879, shows Marguerite with her daughter, Georgette, and her son, Paul (dressed as a girl, as was customary). Paul posed a few months later with his dog for a photograph (above) wearing short hair and dressed for the beach. In his book *Le Temps Retrouvé* (Time Regained) Proust devoted a long description to this painting, even though he disliked Mme Charpentier. He marvelled at this 'luscious painting comparable to Titian's most beautiful compositions' and claimed that the work of Renoir, unlike any other artist's, captured perfectly 'the poetry of an elegant home and exquisite attire'.

'He has returned to the bosom of the Church'

It must be emphasized how much that composition broke with the conventions of fashionable portraits of the time. The artist's younger brother, Edmond, who became a journalist and collaborated on *La Vie moderne*, the periodical started by Charpentier in 1879, made a special point of the fact that this rendition of a young woman and her children had been executed 'in her home, without moving any of the furniture from its usual place, without doing anything to highlight one part of the painting over another'. This was very much the reverse of contemporary official portraits, in which the model was often placed in an artificial setting and given props to bolster his or her image.

Here, on the contrary, apart from the subject itself, the viewer's attention is drawn by the expressive richness of the painting surface. The sheen of the children's flesh tones and hair, the lustre of the textiles, the texture of the materials are all carefully rendered, but the painter carries the eye to less-detailed areas, to swaths of simplified colour, to sections simply sketched in.

The Charpentiers' connections ensured the painting a prominent spot in the Salon, although they could not shield it from the barbs of the critics, who treated the subject with respect while offering their own kind of welcome to the return of the prodigal son. 'Let us not pick a quarrel with M. Renoir, he has returned to the bosom of the Church. Let us

Charpentier's publishing house (its offices on the Rue de Grenelle are shown above in a photograph taken at the turn of the century) started out as an outlet for inexpensive books. Georges Charpentier (left), the son of the founder, had the distinction of publishing Flaubert, the Goncourt brothers, Zola, Daudet, and Huysmans before going bankrupt; he earned a reputation as a warm and generous man. Renoir humorously expressed his gratitude to his patron in a sketch he added at the bottom of a letter to Charpentier (opposite above), showing the painter, mad with joy, leaping on the postman who has arrived with a postal order.

'welcome him back, ignore his composition, and speak only of the colour,' benevolently asserted the critic Arthur Baignières in the very serious *Gazette des Beaux-Arts*; he had previously derided Renoir. It was generally agreed that Renoir was a gifted colourist but a terrible draughtsman.

Charles Ephrussi, patron

It was no accident that the *Gazette* managed a kind word for Renoir. Its owner, Charles Ephrussi, had come to know Renoir through Théodore Duret. The heir of a Jewish banking family originally from Odessa, Ephrussi was

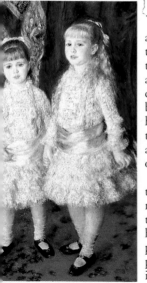

an art historian in love with the work of Dürer. Very up-to-date with the Parisian artistic circles of his day, he defended Degas and Monet, bought their works and used his family and professional ties from Paris to Vienna and Berlin to help attract other buyers.

He extended his patronage to Renoir, who received many portrait commissions through his offices. (Renoir had asked Mme Charpentier permission to show her portrait to Ephrussi before its publication.) Among

Alice and Elisabeth Cahen d'Anvers (portrait 1881, left) were the daughters of a banker whom Charles Ephrussi had introduced to Renoir. It seems that the fee for the picture was late, and Renoir, beside himself, came out with a familiar bit of anti-Semitism in a letter to Deudon, 'As to the Cahens' 1500 francs, if I may say so, I find it a bit stingy. Such meanness is unbecoming. I will definitely keep away from Jews from now on.' The Cahen family was disappointed with the painting and relegated it to the servants' quarters.

them is Renoir's painting of the Cahen girls, a 'modern' portrait, rivalling the proven, universally admired formulas of a Léon Bonnat and other painters trapped in this mode. Uncomfortable in this role, and unsuited to be a society painter, Renoir gave vent to his anti-Semitism.

On the other hand, the painter formed much more solid relations with a different circle, composed of Protestant financiers. Duret probably brought Renoir into contact with another collector also linked with Ephrussi, Charles Deudon.

Paul Berard (left, in a portrait by Renoir of 1880) divided his time between his Château de Wargemont near Dieppe (below), where Renoir made extended visits, and his town house on the Rue Pigalle in Paris. Like his wife, a friend of Mme Charpentier's, he greatly admired Renoir's painting and commissioned from him a series of portraits of his many children. On the birth of Berard's daughter Lucie in July 1880, Renoir made a sketch of the new father (opposite above) in a letter and added, 'Congratulations on my new model; I was hoping for twins.... After all, painting comes first!'

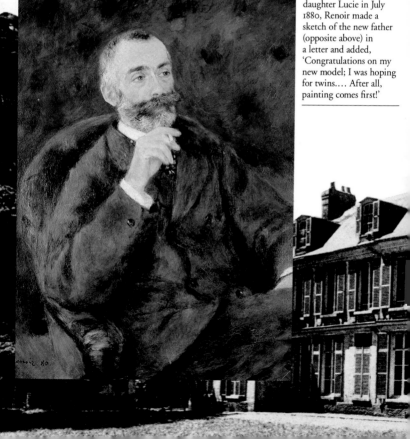

Renoir at the Château de Wargemont

Charles Deudon, who had inherited mines in
Wales, purchased *The Dancer* in 1878. He was
a friend of the man who would become one
of Renoir's main patrons, Paul Berard.
A man of independent means, Berard,
after a brief diplomatic career, divided
his time between Paris and his
property near Dieppe. Renoir enjoyed
his hospitality at the Château de
Wargemont many times at the beginning
of the 1880s, and his warm welcome
there proved favourable to his painting. For
Paul Berard, Renoir made a series of family
portraits, and enjoyed decorating the door panels
and fireplace surrounds of the 18th-century Berard
country house with flora and game. The two
men corresponded often; Renoir
did not hide his problems, and
Berard regretted being unable

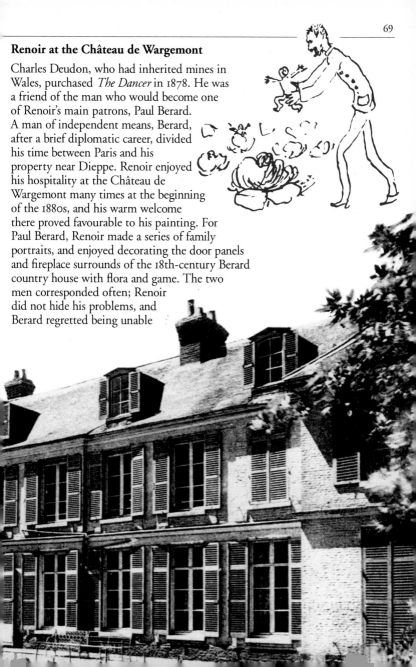

to do more to make his protégé's painting accepted.

Besides this group of patrons, Renoir found help from his dealer, Durand-Ruel, who began buying his paintings on a regular basis, starting in 1881.

Renoir's unaccustomed financial security in this period allowed him the luxury of travelling and of working on various projects that had no guaranteed buyer – such as large-format paintings that could represent him in the Salon.

While visiting the Normandy coast, he began a painting that would be exhibited in the Salon of 1880, *Mussel Fishers at Berneval.* The large-format composition tended towards realism by

virtue of its subject, although Renoir did not exploit the social misery inherent in it. 'There are no poor people in painting,' he said. His lyrical, poetic rendition of the fisherwoman and her children evokes a folkloric sentimentality highly cherished in official circles. However, Renoir left his mark in the intensity of the colours and the airy and luminous space that bathes the figures.

Renoir's *Mussel Fishers at Berneval* (1879, above) already shows the change in his style.

The painter's brother Edmond Renoir, a journalist and author of a book on fishing, may have inspired the drawing below.

The charm of the boating party

After about 1879, the painter went back to the banks of the Seine, at Asnières and Chatou as well as Nogent-sur-Marne, depicting, in a distant echo of the scene at La Grenouillère, men out boating and their attractive companions. These visions of summer, with their brilliant blues and oranges, signalled a stylistic evolution that

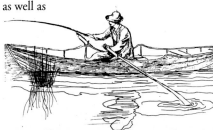

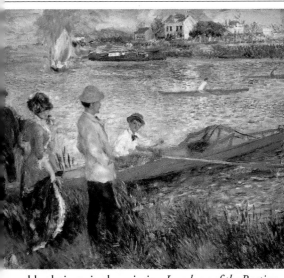

Oarsmen at Chatou (1879, left), a subject that evokes the novels of Maupassant, became one of Renoir's favourite themes from 1879. Working regularly in the open air unleashed the brightness of the artist's palette.

Located on an island in the Seine across from Chatou, the Fournaise restaurant (below) was a central gathering place for boaters. Renoir painted his great *Luncheon of the Boating Party* from its terrace, visible on the left of the building.

would culminate in the painting *Luncheon of the Boating Party* of 1880–1.

It seems likely that this painting, sold in February 1881 to Durand-Ruel, had been started during the summer of 1880. Renoir portrayed a boating party enjoying themselves on the terrace of the Fournaise restaurant, a popular spot on the island of Chiard at Chatou that Maupassant, a regular patron, described in *La Femme de Paul*. Renoir frequented the place himself and painted a series of portraits of the owner, Alphonse Fournaise, and his family. In a letter to Paul Berard, Renoir wrote, 'I'm at Chatou…and I'm doing a painting of oarsmen that I have been longing to do for ages.

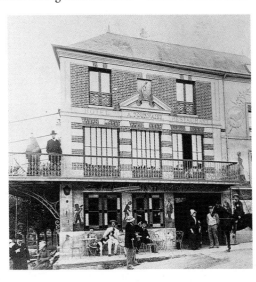

A modern genre scene

The same model, one M. de Lauradour, posed for both *The Luncheon* (c. 1879, left) and *The Rowers' Lunch* (c. 1880, detail above; complete painting on title page), depicting oarsmen and their companion, implying that the pictures share the same milieu. Here, the intimate scene tempts one to 'read' it in the naturalist vein of a Maupassant novel. Contemporary critics constantly interpreted paintings in this literary way. Renoir, on the other hand, saw himself as reviving the genre scene made famous by the 17th century Dutch or the 18th-century French school, though firmly fixing it to his own time with the details of the table setting, the dress of the people and the characterless décor.

Renoir.

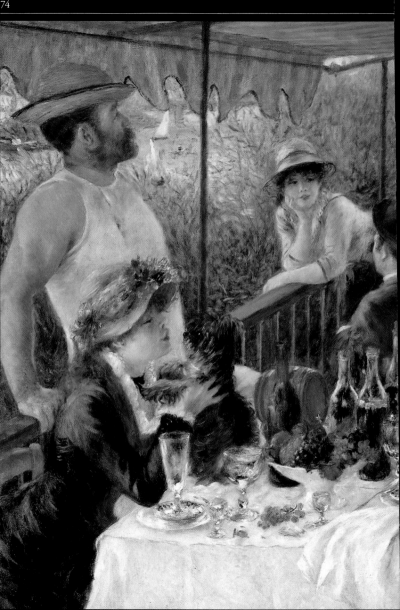

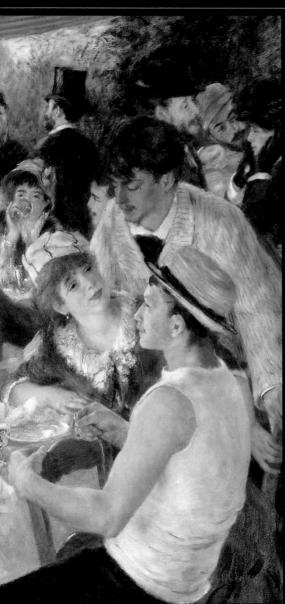

Luncheon of the Boating Party

Of all Renoir's friends and models who posed for *Luncheon of the Boating Party* (1880–1) only two can be positively identified: the oarsman leaning against the balustrade on the left is the son of Alphonse Fournaise, who owned the establishment, and the young woman in front of him playing with the little dog is Aline Charigot, a young dressmaker and Renoir's future wife. What can be said confidently is that in deliberately bringing together a variety of men's hats – cap, straw hat, bowler, top hat – Renoir indicated the social mixture in the animated gathering. Contemporary chroniclers make one think that the Fournaise restaurant – Maupassant called it the 'phalanstery of the oarsmen' – was a noisy and rowdy place. Since painting *At the Inn of Mother Anthony* and *Dancing at the Moulin de la Galette,* Renoir apparently decided to play down the cruder aspects of reality in painting the 'fêtes galantes' of his own time.

'I'm getting somewhat older and I don't want to delay this little feast which I won't be able to afford later on. I don't know if I will finish it, but I've confided my woes to Deudon, who thinks I'm doing the right thing even if the enormous expenditures I'm making prevent me from finishing my painting. It's all a step forward. One must try things beyond one's reach from time to time.'

The work went slowly, as he explained to Berard a bit later: 'I must have another go at this wretched painting because a high-society tart had the nerve to come to

Renoir added to the note below (to an unknown recipient) a list of colours – flake white, chrome yellow, Naples yellow, yellow ochre, burnt sienna, vermilion, madder lake, Veronese green, emerald green, cobalt blue and ultramarine – that corresponds to his palette in the 1880s, from which

Chatou and want to pose [for it]; that cost me two weeks and, in short, today I took her out of it and… I no longer know where I am with it, just that I'm becoming more and more upset.'

black is missing. The flat brushes were for oil painting; the sable brushes (which Renoir characteristically misspelled, calling them 'pinceaux de Marthe' instead of 'de martre') used by watercolourists were in fact also employed for very fine details.

A new style

None of the preparatory drawings remain. Even without them, a close look at the painting itself shows numerous repainted details and leads to the conclusion that Renoir reworked the canvas extensively, altering the poses of the characters or adjusting the tonal values as the work progressed.

Luncheon of the Boating Party has almost exactly the same dimensions as *Dancing at the Moulin de la Galette*,

which underlines both the similarity of their subjects – a crowd outdoors – and the remarkable difference in their styles, even though they are separated by only about five years. In the later painting, the palette is lighter and the composition more assured, the artist having simplified the perspective and, especially, used colour contrasts to define the figures' clearly individualized features. The pains Renoir took to clarify the outlines seem to be in response to criticism levelled against all of the Impressionists for leaving their objects fuzzy and sketchy. At the same time, Renoir had been heavily engaged in painting portraits, which forced him to look for individuality in his figures.

It was not this magnificent painting that represented Renoir at the Salon of 1881 but two portraits (not

Originally called *The Two Sisters*, this painting was dismissed by the critics with coarse jokes. It has since become one of the best known and best loved by Renoir. The models are sitting on the terrace of the Fournaise restaurant, and the work is now known more by the site than by the sisters: *On the Terrace* (1881).

definitely identified) that Renoir, who was about to go abroad, left to Ephrussi to choose. Like Monet and Sisley, he again declined to show with the Impressionists. He explained to Durand-Ruel that the decision was based solely on commercial considerations: 'There are in Paris', he wrote, 'barely fifteen collectors capable of appreciating a painter outside the Salon.'

The light of northern Africa

Renoir's first trip abroad took him to Algeria. Exhausted after working all winter and finishing the double portrait of the Cahen girls, Renoir left Paris at the end of February 1881 in search of sun and exoticism, following the example of one of his favourite artists, Delacroix. The letters he wrote to his friends and patrons demonstrate his love of that country.

Starting in 1880, Paul Durand-Ruel began to buy pictures from Renoir on a regular basis, though they never made any formal agreement. The dealer's account book (below), which records the day-to-day operations of the business, lists the items bought from Renoir in May 1882 on his return from a long journey that took him through Italy, to L'Estaque near Marseilles and finally to Algeria, where he convalesced from a severe bout of pneumonia. The titles of his paintings give an idea of his itinerary; the prices are coded, following the custom of the day.

In the outskirts of Algiers, where he stayed, he found picturesque motifs and wonderful vegetation, 'a mixture of prickly pear and aloes'. The vegetation forms the subject of *Algerian Landscape: The Ravine of the Wild Woman*, named after a café-restaurant on the spot where Renoir painted, outside Algiers. Its deep ultramarine blues suggest shadows that contrast with the bursts of red, orange and emerald green.

Algerian Landscape: The Ravine of the Wild Woman (1881, above). To his great regret, Renoir was only able to sketch a few typical people (below).

Renoir was, however, disappointed that he could not paint as many figures as he wished, as the models used to back away at the last moment. It was not until his second trip, in the spring of 1882, that he managed to draw a few people.

That summer, back in France, Renoir spent most of his time on the coast of Normandy, where he experienced the opposite of the Bérards' warm welcome at the home of Mme Emile Blanche, wife of the famous psychiatrist. He had been invited to Dieppe to work with her son, the

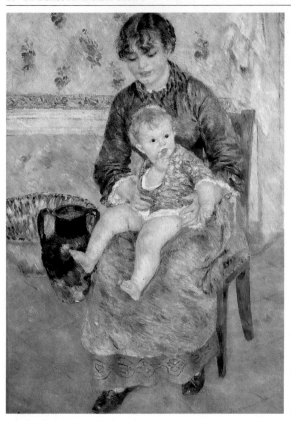

Although today the painting on the left is known as *Mother and Child*, Renoir never called it that, and the young woman holding the child seems a bit young to be the mother. It is certain that it was painted in Naples, probably in November 1881. By this stage on his Italian journey, after having visited Venice and Rome, Renoir was totally captivated by the country. His son Jean recorded his reactions: 'I became weary of the virtuosity of the Michelangelos and the Berninis: too much drapery, too many folds, too much muscle! I like painting that has an air of the eternal about it...but without making a thing of it: an everyday eternity caught at the next street-corner.... The Italians don't deserve any praise for creating great painting. They have only to look around them. The Italian streets are full of pagan gods and biblical figures. Every woman who nurses a baby is one of Raphael's Madonnas.' Renoir's work can in fact easily be seen as a modern version of the Italian master's madonnas.

painter Jacques-Emile Blanche, but in the stiff, reserved household, the artist's rough manners and nervous tics were badly received.

A trip to Italy

At the end of October 1881, Renoir was off again, this time for Italy: 'I've suddenly become a traveller, overtaken by the desire to see the Raphaels.... I've done the North, and I'm going to go down the entire boot.'

The first of November found him at Venice, and thence to Rome, probably by way of Padua and Florence. In Rome, he marvelled at Raphael's frescoes. 'They are

full of knowledge and wisdom' were his exact words. From the end of November he stayed in Naples, making many trips to the museum, where the paintings from Pompeii particularly attracted him.

He ended the year at Capri. There, he learned that Manet had been named a chevalier of the Legion of Honour – his first sign of official recognition – and he hastened to offer congratulations.

His Wagnerian friends in Paris sent the painter to Palermo, where Wagner was working on *Parsifal.* The maestro finally granted him an interview on 14 January 1882 and a sitting of thirty-five minutes the following day. This historic meeting, of which Renoir gave a comical account (see pages 134–7), produced a portrait that the illustrious subject thought resembled 'a Protestant minister', as indeed it does.

Renoir and Cézanne

Soon afterwards, Renoir returned to France via Naples and Marseilles, ending up in L'Estaque, where he worked

In Italy Renoir behaved like a conventional well-behaved tourist-painter, and he laughed at himself when he found himself in Venice painting the Doges' palace: 'That had never been done before, I think. We were queuing up at least six deep.' In Naples, he painted Mount Vesuvius (below), but he could not resist associating that antique image with the most obvious signs of modernity, the carriages that ran by the sea, which was dotted with traditionally rigged boats.

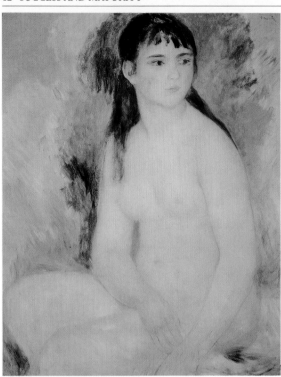

Since it was never finished, it is difficult to date the *Nude* (left) that the sculptor Auguste Rodin bought after seeing it at a collector's home; no doubt he was seduced by the free and simplified lines that call to mind his own watercolours. The importance given to line and the range of tones used seem to place it with the work of the early 1880s.

Seated Bather (opposite left) has often been dated to 1885, but the brushwork seems freer than that of work known from the period. The rocks in the background and the blue-green sea recall the canvases painted in Guernsey in 1883 that Renoir planned to use for future compositions. It may be the case that this bather was painted shortly after the artist's return from the Channel Islands. Here, Renoir was taking up in a different setting the theme of bathers by the sea that he had begun with *Blonde Bather* (opposite right) under the Mediterranean sun during his trip to Italy.

beside Cézanne. It would be hard to imagine two more different personalities. However, Cézanne, who had always studied and copied the great artists of the past and considered the Louvre 'a good book to consult' even while preaching the close observation of nature, had something in common with the man who was 'on fire to see the Raphaels'. Cézanne's influence clearly made Renoir pay more attention to the structure of his compositions and led him to simplify, a direction already suggested by the monumental painting he had seen in Italy.

Renoir fell seriously ill with pneumonia while with Cézanne. His doctor advised him to convalesce in Algeria, and he spent most of March and April there, painting throughout his trip.

The lesson of Italy

Renoir was represented at the Salon of 1882 by a portrait, passing up the seventh Impressionist exhibition. However, he could not prevent Durand-Ruel, who had organized the Impressionist show, from contributing twenty-five canvases from his own collection, including *Luncheon of the Boating Party*.

He spent the summer at Normandy again, where he saw the Berards, the Blanches and, with Durand-Ruel, Monet, who was working in Pourville. His friends noticed a change in his style when they saw a *Bather* that Renoir said he had painted on a boat to Capri, under the sun. He did not identify the model, but the young woman herself, Aline Charigot, later confided to Julie Manet, Berthe Morisot's daughter, that she had taken a trip to Italy with Renoir. At the time, Renoir did not tell a soul, and he carefully hid all trace of their relationship for many years.

A comparison of this *Bather* and the study *Nude in Sunlight* shown at the second Impressionist exhibition of 1876 reveals the distance the artist had travelled.

Blonde Bather (1881, below) in all likelihood is the painting that Renoir painted in Capri with the very young Aline Charigot as the model. (Can some meaning be read into the gold ring the sitter wears?) Although Renoir and Aline were not married until 1890, the young woman later referred to this trip to Italy as her 'honeymoon'. This painting is one of the first to signal the artist's return to a classicism inspired by Italian art and the memory of Ingres.

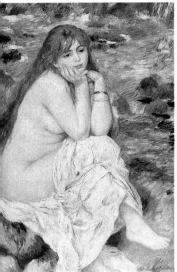
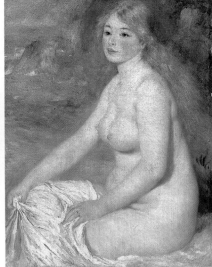

Instead of a hazy figure under a dappled light that breaks up the forms, this nude has a generous, monumental presence, set down clearly with a well-defined outline. The transposition has been sensitively achieved; neither boat nor bay of Naples can be seen – there is only a classical theme in an undefined landscape. The canvas seems to correspond to a goal mentioned by the artist in an 1882 letter to Mme Charpentier: to rediscover 'the nobility and simplicity of the ancients'.

Variations on the dance

After his Italian trip, Renoir began three large canvases that he finished in the spring of 1883: *Dance at Bougival* and its two counterparts, *Dance in the City* and *Dance in*

CATALOGUE

DE

L'EXPOSITION DES ŒUVRES

DE

P.-A. RENOI

R enoir's first one-man show (catalogue above) took place in April 1883 at Durand-Ruel's gallery. The owner's sons Charles and Georges (below), as well as Joseph, soon became partners.

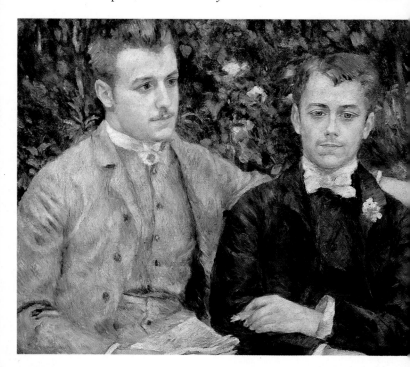

the Country, which are related to *Luncheon of the Boating Party* in theme and style. For *Dance at Bougival* and *Dance in the City* Renoir used a young model named Marie-Clémentine Valadon. Encouraged by Degas, she would later become a painter herself, under the name Suzanne Valadon. In December 1883, she gave birth to a boy, Maurice Utrillo, whose father, she sometimes hinted, could have been Renoir. In *Dance in the Country*, the dancer in the arms of Renoir's friend Paul Lhôte is probably Aline Charigot. The two counterpart *Dances* were exhibited in a rented space on Boulevard de la Madeleine in April 1883 on the occasion of Renoir's first one-man show, organized by Durand-Ruel. The dealer had decided to show 'his' painters in succession – Boudin, Monet, Pissarro, Sisley – a new concept.

Dance at Bougival was shown somewhat later, also by Durand-Ruel but this time in Dowdeswell Gallery in London, with a group of ten works by Renoir. This was not Renoir's London debut; his dealer methodically explored all the markets, so that the same year he had paintings by Renoir displayed in Boston and Berlin as well.

Jersey, Guernsey and the Côte d'Azur

Renoir travelled again in 1883. At the end of the summer he went to the Channel Islands, first to Jersey, then to Guernsey, where he stayed for a month, gathering 'canvases and sketches to make paintings with in Paris…a source of authentic and appealing motifs that I can use,' as he told Durand-Ruel.

At the end of the year he accompanied Monet to the Côte d'Azur; together they travelled from Marseilles to Monte Carlo by stages, straying as far as Genoa by way of Bordighera. Although they were gone only two weeks, both artists managed to paint. The 'painter of figures', as Renoir described himself, happily made studies of the 'pretty landscapes, with distant horizons and the loveliest colours.…

In 1883 Renoir created a series of works on the theme of the dance. *Dance at Bougival* (overleaf left), which shows Suzanne Valadon, was reproduced in a small print by Renoir around 1890 (below). To the world of the boaters, evoked once more in *Dance in the Country* (overleaf centre), very likely with Aline Charigot, Renoir contrasted his *Dance in the City* (overleaf right), with Suzanne Valadon – a taffeta dress against those of cotton or cretonne.

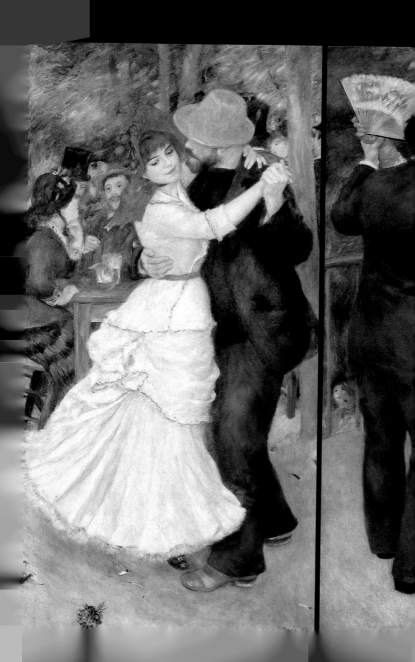

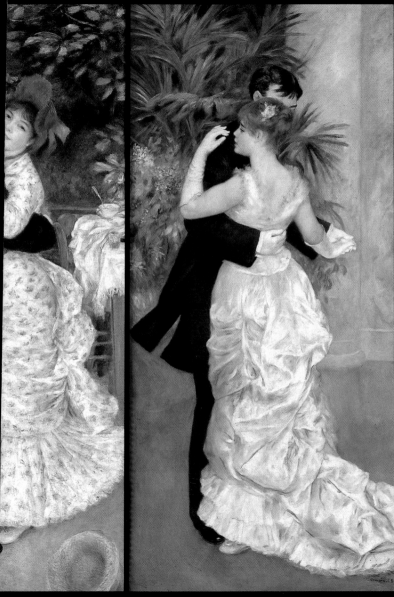

Unhappily, our meagre palette wasn't up to it. The beautiful russet tones of the sea came out muddy on the canvas no matter how much pain we took.' They next visited Cézanne, who had exiled himself in Provence.

Renoir went back to Paris in time to see the posthumous exhibition of Manet's work at the Ecole des Beaux-Arts and to celebrate his success, although he regretted being unable to 'treat myself to a memento of a lost friend' at the subsequent sale.

Guernsey (above) reminded Renoir of a 'landscape by Watteau'. In a letter to Durand-Ruel (a section is reproduced below), the painter professed himself enchanted by this 'source of authentic and appealing motifs'.

Renoir with his family

Around this time, Renoir left his apartment on the Rue Saint-Georges for one closer to Montmartre. He had a studio at 37 Rue de Laval (today Rue Victor-Massé). Aline Charigot gave birth to their first son, Pierre, at 18 Rue Houdon, on 21 March 1885. Gustave Caillebotte,

one of Renoir's few friends to know of the existence of Renoir's family, was the child's godfather.

This change in his life – at the age of forty-four – corresponds to a period of questioning and stylistic transformations exemplified by the large painting *The Bathers*, shown in the spring of 1887.

The Umbrellas (opposite) has the peculiarity of having been painted in two styles: the right side around 1881, the left and upper portion in the 'dry' style of 1885.

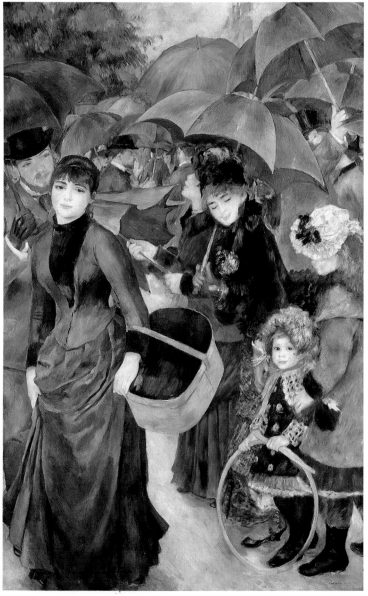

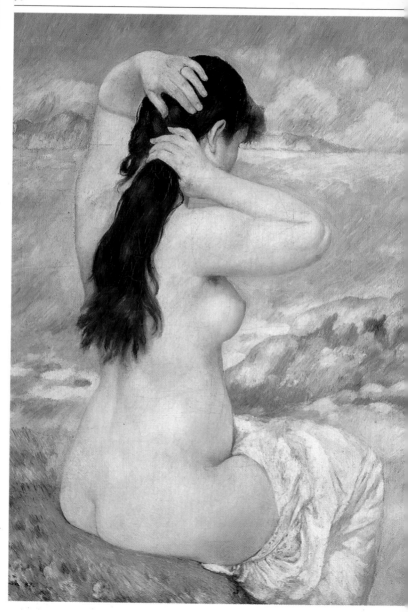

Around 1883, a crack appeared in my work. I had gone as far as I could with Impressionism and had come to the realization that I didn't know how to paint or draw. In short, I had reached an impasse.'

Renoir to Ambroise Vollard

CHAPTER 4

THE INGRESQUE PERIOD

Among all the nudes of the experimental time that has been called Renoir's 'Ingresque period', *Bather Arranging her Hair* (1885) displays the sharpest outlines. The light tonalities of the painting call to mind the frescoes Renoir had so admired in Italy. However, the artist could not resist animating the landscape around the polished curves of the flesh with nervous brushstrokes.

Raphael or Ingres?

Renoir's Ingresque, or dry, period culminated
in 1887 with the exhibition of his large
painting *The Bathers*. It had its origins at
the beginning of the 1880s, a time when all
the Impressionists were seeking to revive
their work. Renoir's style had undergone
a profound transformation, which the trip
to Italy only confirmed.

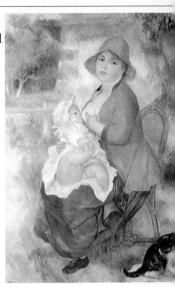

Renoir's letters make constant reference,
especially after 1883, to the problems he
was having in finishing any of his paintings
to his satisfaction. He destroyed many of
them, all the while resolutely continuing
his quest. His questioning also took on a
theoretical aspect.

In 1884 Renoir had dreamed of creating
a new association of artists, the Société des
Irrégularistes, based on his old idea that
modern society, with its emphasis on rules,
was the source of all decadence. He wanted to publish a
Summary of the Grammar of the Arts, but it never reached
fruition. He thought that modern teaching methods had
not managed to replace the old practice of apprenticeship
in a master's studio; he felt this lack for himself, repeating
over and over again his wish to become a good 'worker'
of painting, something his artisanal background had
given him a glimpse of.

This nostalgia for a vanished era was, in fact, common
to the period, in progressive as well as reactionary circles,
and Renoir did not have a coherent solution to suggest
– except, implicitly, in his work.

Pierre, Renoir's first
son, was born in
March 1885. Throughout
the following summer,
spent at Essoyes, Renoir
made many studies of
Aline nursing the child
(below). The painting
above is also dated 1886.

Children's Afternoon at Wargemont

One of the earliest paintings to display clearly Renoir's
new direction is a portrait he made of Paul Berard's
daughters in 1884 called *Children's Afternoon at
Wargemont*. It used the same format as *Luncheon
of the Boating Party* and was only slightly smaller
than *Portrait of Madame Charpentier and her Children*,
indicating the work's ambitious nature. The eye is
initially struck by the clear silhouettes of the figures,

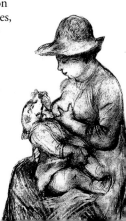

organized into a strongly decentralized composition, but it is soon diverted by the brilliant tones, few in number and essentially cold. The props are charged with the same intensity as the figures, which are highly simplified. The light is strong but even. The simple decorative rhythms of the composition may be meant to evoke Italy's great tradition of mural painting, from the ancient frescoes of Pompeii to Raphael and Tiepolo, which Renoir had just discovered in his haphazard survey.

His renewed interest in a firm and assured line could also have arisen from the paintings of Ingres in the Louvre, works that Renoir had always admired.

The Bathers

Renoir carried out his experiments using the nude, 'one of the forms indispensable to art', he asserted to Julie Manet at the time. Around 1885, he began preparing for *The Bathers*. For the first time, an entire series of

Children's Afternoon at Wargemont (1884, above) was the most important commission Renoir received from Paul Berard. Painted at the Château de Wargemont, it portrays Berard's three daughters: Marthe, on the right, is sewing; Lucie, the youngest, stands in front of Marthe holding her doll; and Marguerite, on the left, is looking at an album. The painting's modernity derives from the simplicity with which the interior – at once elegant and countrified – is represented and from the bold harmonies of the figures and the decor.

drawings and studies for a large composition of Renoir's is known, which indicates that he had changed his work habits as well, placing more importance on his studio work. The composition was taken from a bas-relief, *Nymphs Bathing* (1668–70), by François Girardon that decorated a pool in the park of Versailles. The spirit of François Boucher's *Diana at the Bath* in the Louvre can also be discerned.

Girardon's *Nymphs Bathing* at Versailles (above) was cited in Renoir's day as a source of inspiration for *The Bathers*.

'One must paint according to one's own time. But it's at the museum that we get our feeling for painting, something that nature alone can't give us,' said Renoir. The composition is also a homage to Ingres. The smooth surface, with its enamelled and exquisitely finished touch, recalls that of the master and has nothing

Renoir's *The Bathers* (above) was much criticized when it was exhibited in June 1887 at the gallery of Georges Petit, Durand-Ruel's rival.

in common with the surface effects Renoir had sought ten years earlier. *The Bathers* expresses an ideal beauty completely divorced from historical or geographical context; it marks Renoir's independence from a naturalism that had up to this point remained the keynote of his compositions. His interest in decoration and the notion, dear to him, of the interdependence of the arts finally broke through in the subtitle to the work: *Essay in Decorative Painting*. This commentary could also be interpreted as a way to head off the critics (by stating that it was an experimental work) or as a bid for the official plum of which every artist dreams, to be awarded the task of creating a monumental decoration.

The Ingresque line and porcelain tones of *The Bathers* perplexed Renoir's patrons without winning him new converts from more conservative circles. Durand-Ruel tried to turn him from his new path. The dealer had suffered great losses in the resounding failure of France's major bank, the Union Générale, which almost brought him down with it.

Renoir remained faithful to Durand-Ruel, but, like Monet and Pissarro, he tried to escape his domination by participating in the International Exhibition of Painting and Sculpture beginning in 1886. This exhibition was organized by a committee of artists and for several years had been held in the galleries of Durand-Ruel's rival, Georges Petit. This was where *The Bathers* was first shown to the public, in 1887.

Summer in the country

Renoir continued to spend the summer in search of new ideas. In 1885 and 1886 he took his family northwest

'I'm sympathetic to the effort given to experimentation; it is good to wish not to remain fixed in the same place. But [Renoir] has concerned himself only with line here; the figures are separated from one another with no consideration given to what unites them; as a result, it's incomprehensible.'
Pissarro. Letter, May 1887

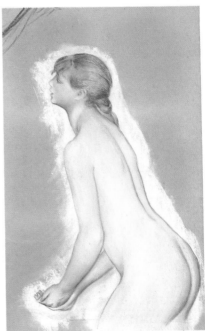

Numerous studies for *The Bathers* were made. Some were simple sketches, others, like *Study of Splashing Nude* (above), were more elaborate drawings.

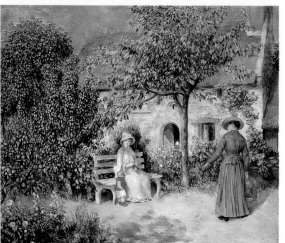

During the summer of 1886, Renoir (shown below in a photograph of the period) rented the Maison Perrette at La Chapelle-Saint-Briac in Brittany and painted in the garden, using an extremely detailed technique reminiscent of that used for *The Bathers*. Aline, Pierre and a neighbour are portrayed in the painting on the left.

of Paris, near Giverny, where Monet already lived and where he could see Cézanne again. In 1886 he made a 'tour of northern Brittany' and stayed at La Chapelle-Saint-Briac long enough to do some painting. In 1888 and 1889 (the exact chronology here is unclear) Renoir made several visits to Cézanne in Aix-en-Provence and followed his host's example in painting Mont Sainte-Victoire, evoking 'the dryness with the olive tree, which follows the weather, drab in dull weather, lively in the sunshine, silvery in the wind'.

Essoyes: working in the country, returning to a more supple style

In the autumn of 1885, Renoir visited Essoyes for the first time. Aline Charigot had been born in this village in the Aube, a region southeast of Paris. He returned many times and finally bought a house there. The bohemian who had 'loved the kind of set-up that you could move in a handcart, and which often was not worth moving at all' had become a homeowner after becoming the father of a family. Renoir enjoyed this rustic milieu, whose inhabitants found him surprising, and the house in

Essoyes, where he set up a studio, became a permanent part of his life.

While working at Essoyes, Renoir went back to a more supple style, bringing together line and colour. 'I have been chatting with Renoir for a long time. He confessed to me that everyone, Durand, old patrons, came complaining to him, deploring his efforts to escape from his romantic period,' wrote Pissarro to his son Lucien in October 1888. Soon afterwards, Renoir settled in at Essoyes with the aim, he said, of 'retiring to the country and fleeing the expensive models of Paris [and painting] laundresses, or rather washerwomen, on the banks of the river'. He told Durand-Ruel, 'I think it will work this time. It's very soft and coloured but clear.'

The presence of little Pierre in *The Washerwomen* helps date the painting to about 1888, a time when Renoir, while retaining the clear tones of his Ingresque palette, gradually returned to a softer delineation of volumes and contours, as he explained to Durand-Ruel. Renoir painted this canvas, which evokes a rural, idealized world populated by active women, in Essoyes, where Aline had grown up; Renoir later told his son Jean that he only appreciated women 'who do not know how to read'. Renoir liked living at Essoyes among the peasants, who first found him startling but were quick to adopt him. Jean Renoir wrote at length about family life at Essoyes. The painter is buried there, in the village cemetery, near his loved ones.

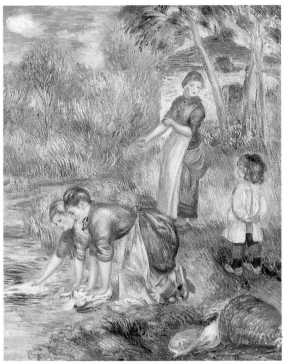

A meeting of three creative talents: Degas took the photograph on the left. His reflection is visible in the mirror behind Renoir, seated, and Mallarmé, standing, who posed 'fifteen minutes in the light of nine oil lamps', according to Paul Valéry. The session took place in 1895 at 40 Rue de Villejust, the home of Julie Manet, whose mother, Berthe Morisot, had just died. Morisot had introduced Renoir and Mallarmé.
The painter often confessed that he did not understand much of Mallarmé's poetry, although he greatly enjoyed the man's company. For his part, Mallarmé admired Renoir's painting and made an effort to make Renoir's painting better known. Also, Degas and Renoir often met and conversed at Morisot's apartment and later at her daughter's, but their friendship was not close, unlike Renoir's with Monet and Cézanne; the two had little in common besides painting.
They fell out at the end of 1898 when Renoir sold a pastel by Degas left him by Caillebotte.

The end of Impressionism?

Renoir did not participate in the eighth and last Impressionist exhibition in 1886. Only a few of the original group, notably Pissarro and Degas, showed paintings at this point, and it was mostly the younger artists, especially Gauguin and Seurat, who drew critical attention. However, in 1884, at Monet's suggestion, the Impressionists took to meeting once a month at the restaurant of the Café Riche. This gathering of the early artists and patrons was a sentimental way of closing ranks.

Around 1886 Renoir became a regular at the private soirées that Berthe Morisot, whose painting reveals his influence, began to hold in her Paris apartment on

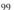

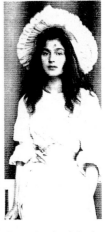

Renoir painted *Berthe Morisot and her Daughter, Julie* (left) in 1894. When Morisot died Julie (photograph above) was left an orphan at sixteen. With Monet, Mallarmé and Degas, Renoir took part in the hanging of a posthumous exhibition of Morisot's work at Durand-Ruel's in 1896. Along with Mallarmé, Julie's tutor, Renoir looked after the girl, often taking her on family holidays to Brittany and giving her painting lessons. Julie spoke of him affectionately in her *Journal* and displayed admiration for his painting whenever she visited his studio.

the Rue de Villejust. That summer he was her guest at Mézy, a small village near Mantes, just west of Paris. Renoir made several portraits of Julie Manet, including one with her mother in 1894. Berthe Morisot brought Renoir and the poet Stéphane Mallarmé together. Renoir painted a portrait of the poet and illustrated the frontispiece of a volume of *Pages* published in 1891. Mallarmé wrote for Renoir:

> Villa des Arts, near the Avenue
> De Clichy, Monsieur Renoir paints
> Who, faced with a bare shoulder,
> Is not in a black mood?

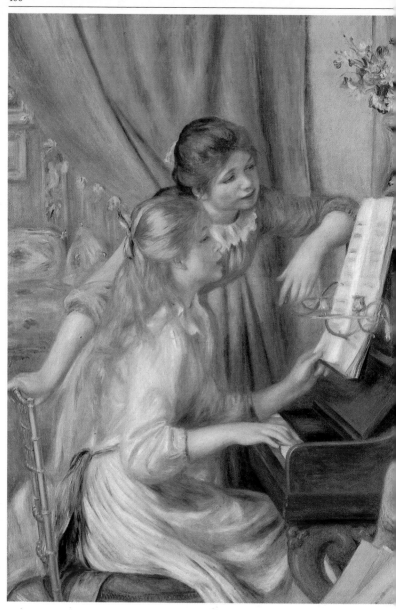

I have returned to the old painting, soft and light, for good.... It's nothing new, but it follows the style of 18th-century pictures.... (A lesser Fragonard).'

Renoir
Letter to Durand-Ruel, c. 1888

CHAPTER 5
OFFICIAL RECOGNITION

Mallarmé convinced the director of the Beaux-Arts, Henri Roujon, to buy this version of *Young Girls at the Piano* (1892, left) for the State in 1892: 'It is my feeling, as well as the unanimous opinion of everyone else, that you cannot be sufficiently congratulated on having chosen such a definitive, refreshing, bold work of maturity for a museum,' wrote Mallarmé to Roujon.

'Idealist? Naturalist? Whatever you like…. He has created wonderful bouquets of women and flowers'

At the beginning of the 1890s, Renoir painted peasant women going about their work in the country or girls who looked as though they came from the city playing the piano, reading, chatting or picking flowers. Although signs of the time – the end of the 19th century – are in evidence (the piano, hats and the game of pushing hoops with a stick), Renoir apparently did not want to weigh his figures down with naturalistic details. The bucolic mood and tranquil harmony of these paintings recall both Corot's idyllic countrysides and the well-known outdoor entertainment scenes called 'fêtes champêtres' of 18th-century French painting. Renoir himself mentioned the influence of the fêtes, and such references to tradition appear repeatedly throughout the rest of his career.

Renoir managed to work himself out of his 'dry' period with these themes, returning to a surface that was more supple, sometimes velvety, more suited to the ideal world he depicted.

In addition, Renoir continued to paint nudes, his favourite theme. In 1892, the Nabi painter and theorist Maurice Denis accurately summed up the new spirit

The Apple Seller (c. 1890, above left) and *Gathering Flowers (In the Meadow)* (c. 1890, top right and detail above) illustrate perfectly what Renoir meant by a 'suite of 18th-century paintings'.

of Renoir's painting: 'Idealist? Naturalist? Whatever you like. He has shown that he can confine himself to translating his own emotions, presenting all of nature and all of illusion with his own methods: using the pleasures of his eyes, he has created wonderful bouquets of women and flowers.'

New critics, new patrons

The admiration expressed by Maurice Denis, who was just beginning his career (he was born in 1870), demonstrates that Renoir's work continued to attract the younger generation of artists and critics of the Symbolist and Decadent schools. Among the critics who wrote about Renoir were Albert Aurier, also one of the first to appreciate Van Gogh; Teodor de Wyzewa, the translator of *The Golden Legend*, who, like Aurier, was close to Symbolist circles; the novelist Octave Mirbeau; and Thadée Natanson, one of the founders of *La Revue blanche*.

Julie Manet was greatly taken with the double portrait of the daughters of the painter, collector and music lover Henri Lerolle, *Yvonne and Christine Lerolle at the Piano* (1897, below), which she saw in Renoir's studio in October 1897. She wrote in her *Journal*, 'It's gorgeous. Christine [on the right] has a delightful expression; although it's not a good likeness of Yvonne, her white dress is gorgeously painted. The background, with Degas' small dancers in pink with their pigtails and the races, is painted lovingly.'

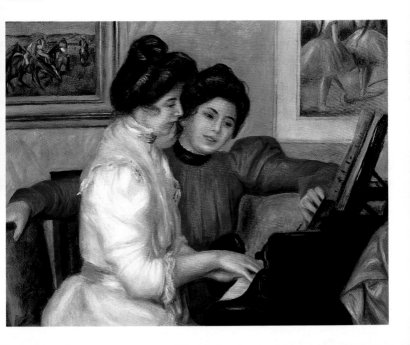

At the same time, Renoir's work was also attracting new patrons, most of whom took an interest in other Impressionist artists as well. They included Georges Viau, a Parisian dentist, and François Depeaux, a businessman from Rouen who owned *Summer* and *Dance at Bougival*. Although Depeaux was forced to sell his collection in 1906, he still managed to leave a group of Impressionist paintings to the Musée des Beaux-Arts in Rouen.

Among all the collectors, the one with whom Renoir had the closest relationship was Paul Gallimard. Octave Mirbeau described him thus in 1900: 'He collected books, paintings and income.' After buying works by Renoir at Durand-Ruel's in 1889, Gallimard soon befriended the artist, even taking him along on a trip to Madrid in 1892. He invited Renoir to his family estate in Bénerville (Normandy) and commissioned him to paint many portraits of his wife. Decorative projects were planned, although none would be realized.

Unlike Renoir's other collectors, Paul Gallimard apparently did not have his portrait done by the artist. He is memorialized instead by a 1916 bust by Léon-Ernest Drivier (left) and a portrait by Eugène Carrière, in that painter's allusive style. On the other hand, Renoir made at least two portraits of Mme Gallimard. The exquisite one shown below dates from 1892.

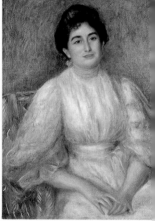

R enoir was photo-graphed sitting on the steps to his studio at the Château des Brouillards in Montmartre (opposite) about 1895 by Martial Caillebotte, Gustave's brother.

The Château des Brouillards

At the end of 1889, Renoir and his family moved to 13 Rue Girardon in Montmartre, in a building surrounded by gardens with the poetic name Château des Brouillards (Foggy Castle). On 14 April 1890 he married Aline Charigot at the administrative office of the ninth arrondissement, making their son Pierre legitimate. Old friends served as witnesses – Franc-Lamy, Lhôte, Lestringuez and the Italian painter Federico Zandomeneghi.

Even married, Renoir remained discreet about Aline's role in his life, to the amused curiosity of the solidly bourgeois Berthe Morisot. His family did become

the focus of his pictorial world, however, especially after the birth of his second son, Jean (the future filmmaker), on 15 September 1894. Georges Durand-Ruel, son of the dealer, as well as the dealer himself stepped in as godfather, and Jeanne Baudot, the daughter of a doctor, was the godmother. She had become a student of Renoir's, and she would write a book of memoirs on the artist.

At this time, a cousin of Mme Renoir's, Gabrielle Renard, came to live with the family to help care for Jean and run the household. She became Renoir's principal model until her marriage in 1914. A third son, Claude, was born at Essoyes on 4 August 1901.

Apart from their many stays at Essoyes, the Renoirs left Paris in the summer for Brittany or

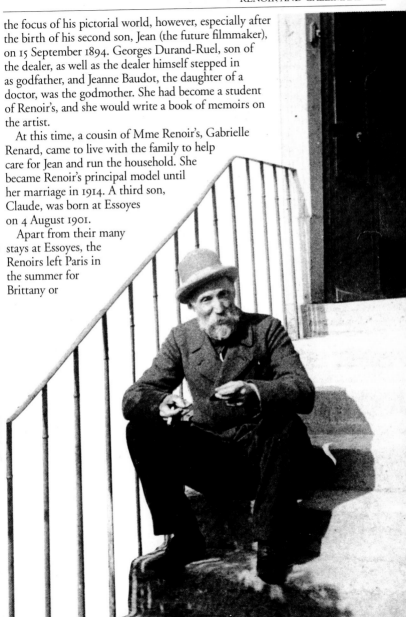

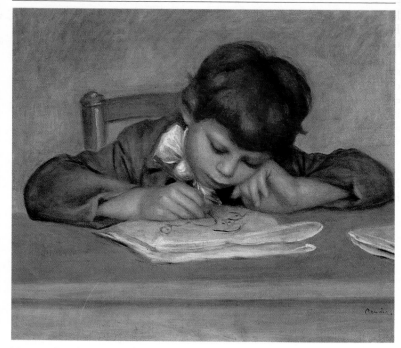

Normandy, where Renoir continued to paint. Julie
Manet stayed with the Renoirs many times.

Renoir aged prematurely. His face became partially
paralysed, and he already suffered from the early
stages of rheumatism in his
legs and hands; it would
become much worse.

Above: *The Artist's
Son Jean Drawing*,
painted in 1901.

Renoir at the museum

The last decade of the century
also brought Renoir official
acknowledgment. While public
recognition of his work was
limited, he was not treated with
the fierce ostracism of the early
Impressionist days. At the end
of 1891 or the beginning of 1892,
Mallarmé and the critic Claude

Roger-Marx, who was in the administration of the Beaux-Arts, convinced the director, Henri Roujon, to buy a painting from Renoir on behalf of the State.

This was not the first time that the administration had shown interest in the artist. Roger-Marx had sought him out at the occasion of the Centennale, the retrospective exhibition of French art organized for the World Fair held in Paris in 1889. At the time, the artist told him, 'I find all my work terrible and it would make me feel infinitely worse to have it shown.'

Then, in 1890 Renoir's friends appealed on his behalf to have him decorated by the State; he refused it. Monet wrote to Caillebotte at the time, 'I congratulate him.... It would have been helpful to him, it is true.

In 1896, Renoir painted his family (below) in the garden of his house in Montmartre. Mme Renoir, shown wearing an elaborate hat (perhaps arranged by Renoir himself, who loved to dress his models), stands arm in arm with her son Pierre, who would become an actor. Gabrielle crouches on the right with little Jean, who is still wearing a dress in this picture. The figure of a young neighbour (right) balances with that of Pierre. Claude (known as Coco) had not yet been born.

Opposite below: *Renoir Painting his Family at his Studio, 73 Rue Caulaincourt,* a small 1901 painting by Albert André.

Overleaf: over the years, the nudes that Renoir painted seemed to become more opulent (pages 108–11, in the order mentioned): *Young Girl Bathing* (1892), *Bather* (1895) and even *Sleeping Bather* (1897), according to critic Gustave Geffroy, invoked 'little creatures of instinct, at the same time children and grown women… sensual without sin'. Another critic, Julius Meier-Graefe, called *Bather* (c. 1903) 'a transfigured Rubens'.

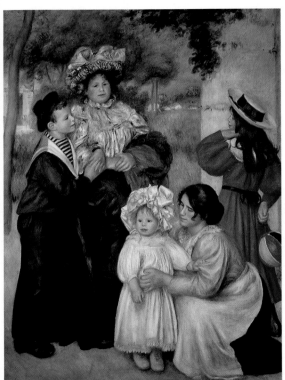

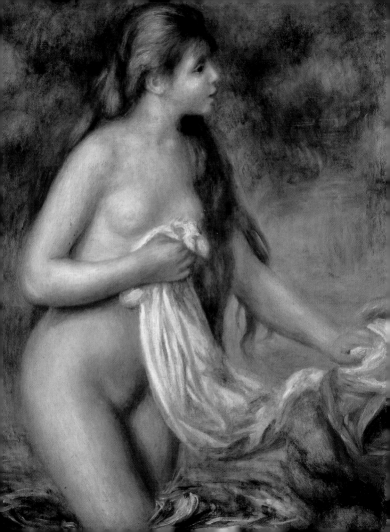

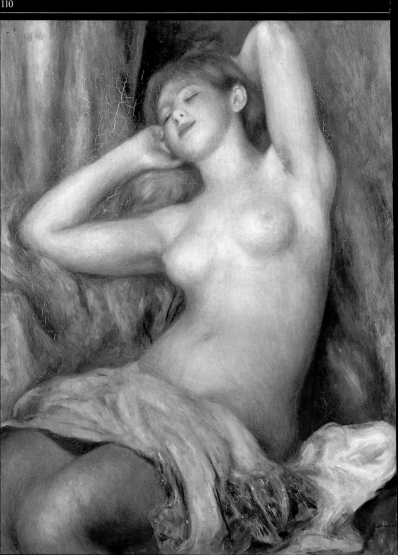

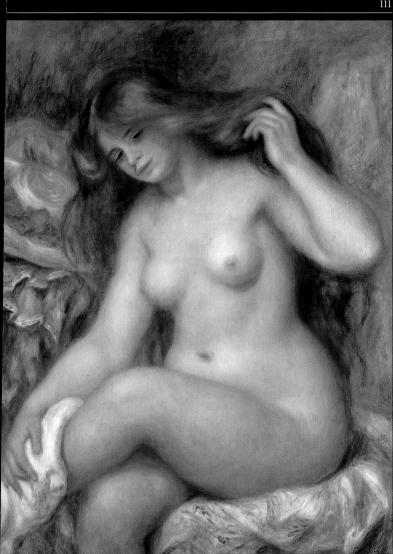

However, now he must succeed without it, which is much better.'

Renoir responded to an informal commission from the administration by painting no fewer than five versions of *Young Girls at the Piano* in oils, plus one in pastels. The purchase was finally made on 2 May 1892 for the sum of 4000 francs.

Renoir was only the second living artist from the original Impressionist group from whom the State had bought a painting (the first was Sisley).

In order to get the State to accept the gift of Manet's *Olympia* in 1890, it took all the perseverance that Monet could muster, as head of the group of private subscribers who had bought the painting from the artist's widow. On that occasion, Monet had asked Renoir for a contribution. Renoir first excused himself by saying that he could not afford it, but he ended up sending in a small amount.

The Caillebotte bequest

Gustave Caillebotte died in February 1894, leaving his collection of works by his friends Cézanne, Degas, Manet, Monet, Pissarro, Renoir and Sisley, plus two drawings by Jean-François Millet, to the State. His bequest revealed how Impressionism was perceived in the eyes of the public. Renoir was involved on two levels: as artist, since the collection included eight of his paintings – among them *Dancing at the Moulin de la*

Woman Playing the Guitar (left), painted about 1896–7 and acquired by the Musée des Beaux-Arts, Lyons, in 1901, reveals Renoir's extravagant taste for imaginative costumes.

Opposite: Renoir made a self-portrait in 1899 (left). The face shows the marks of age, and the body of the painter, not yet sixty, is already that of an old man whose severe rheumatism has made him dependent on a cane (photographs right).

In 1894 Renoir served as executor of Gustave Caillebotte's estate, with Gustave's brother Martial, whose children he painted in 1895 (below).

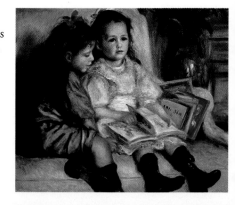

Galette, The Swing and *Nude in Sunlight* – and as executor. In the will he had made in 1876, Caillebotte specified that the paintings should be placed 'neither in a storeroom nor a provincial museum but rather in the Luxembourg [then the national museum of modern art] and later in the Louvre'.

As Caillebotte had foreseen, the government did not want to display the entire collection of more than sixty paintings. After quite a bit of wrangling (of which Renoir soon grew weary), accompanied by a great deal of commentary in the press – both for and against – forty works were finally presented to the public in 1896. In spite of official reluctance, Impressionism had finally entered the museum.

Caillebotte's bequest contained an unexpected benefit for Renoir, as Caillebotte had stipulated that for his

work as executor, Renoir should be permitted to choose for himself a work from the collection. He added, 'My heirs insist that he take something important.' Renoir selected a pastel by Degas, *Dance Lesson*. Soon after, in need of money, he sold it to Durand-Ruel. Degas found out and never forgave Renoir.

'I let myself be decorated'

'Whether I've done something stupid or not, I count on your friendship,' Renoir wrote to Claude Monet in August 1900. Renoir had been nominated as a chevalier of the Legion of Honour, and his old friend Paul Berard came to deliver the insignia. Author Jules Renard reported Renoir's reaction: 'My, my! Yes, you lower your nose, you see the red [ribbon], and then, good heavens, you lift up your head again!'

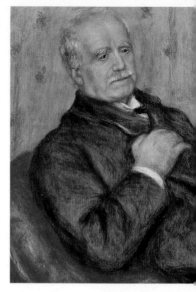

This honour followed the display of eleven paintings by Renoir at the Centennial Exhibition of French Art, a show officially linked with the World Fair in Paris. Renoir, who continued to distrust the administration, had initially refused to participate, as had Monet and Pissarro, but his friend Roger-Marx, a longtime supporter, persuaded him to change his mind.

Renoir's final offering at the spring Salon was *The Daughters of Catulle Mendès* (1888) in 1890. He no longer needed that forum to present his work. At the same time, he declined to join the ranks of the dissident branch of French artists who created the Salon de la Société Nationale des Beaux-Arts, headed by Pierre Puvis de Chavannes and Jean-Louis-Ernest Meissonier, the same year.

He preferred groups that could be described as avant-garde, like Les XX from Brussels, where he exhibited in 1890, even though he did not share the predilection of the organizer, Octave Maus, for Seurat and his followers. Renoir continued to send works to the successor of

Renoir made numerous portraits of Paul Durand-Ruel's children, but it was not until 1910 that he painted the portrait of the man (above) who had discovered Manet and the Impressionists – and had supported Renoir unflinchingly since 1872.

Even if he did business with other dealers Renoir was unquestionably the most faithful of Paul Durand-Ruel's painters, giving him the first look at his works until the end of his career. Renoir seems to have been much less calculating in his business dealings than Degas or Monet.

Les XX, La Libre Esthétique, in 1894 and 1904, and he also contributed to the Salon d'Automne in 1904, 1905, 1906 and 1912.

For the most part, however, Renoir displayed his work in private galleries.

'The dealers have good qualities, whatever one may say about them, since the death of the Medicis…'

'If the wretched painter had to run after the collector before the collector came to him, he would die of hunger.' Renoir was thinking above all of Durand-Ruel, his 'old friend', in his praise of the art dealer. Durand-Ruel clearly had a major influence on the artist's output – not only through his support but through his demands as well – consistently pushing for finished paintings rather than sketches, as Renoir himself acknowledged.

Helped by his son, Paul Durand-Ruel organized several solo exhibitions of Renoir's work, in 1891, 1892 (a major retrospective of 110 paintings), 1896, 1902 and 1908 (at his New York gallery, where he had been active since 1886). Then there were the group shows, notably in New York in 1900 and especially in London in 1905, at the Grafton Galleries.

When Paul Durand-Ruel took over his father's business as art dealer in 1865, the art trade as it is today barely existed. Durand-Ruel was a pioneer in the field, not only because he was the first to recognize talented artists rejected by popular opinion but also because he set in place all the commercial strategies to support 'his' painters: shoring up prices in public auctions, organizing solo exhibitions (like the one at the Grafton Galleries in London in 1905, below), using publications and perpetually looking for new audiences in France and other countries.

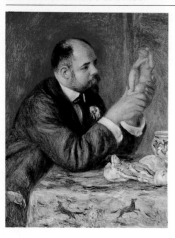

Unfortunately the London show was not a commercial success, despite the accumulation of masterpieces it offered.

In addition to Durand-Ruel, two other dealers had established lasting bonds with Renoir: Ambroise Vollard and the Bernheim-Jeune brothers.

Vollard...

Ambroise Vollard gave up his law studies to learn the basics of the trade with a dealer before opening his own shop on the Rue Laffitte, the hub of the Parisian art market. While offering the work of the then-unknown painters Gauguin and Van Gogh, he held the first solo exhibition of Cézanne in 1895. Renoir went to see the latest paintings of his friend there and found in them 'an indefinable closeness with Pompeiian art, so unpolished and so wonderful'.

Like Manet's widow, Monet, Degas and Pissarro, Renoir at first gave Vollard only minor works to sell and then, as he got to know the young dealer, mined a more popular vein. Over the following years Vollard's shop, with its dusty display case and its piles of paintings turned towards the walls, became legendary, and its French, German, American, Russian and Japanese clients began to pay substantial prices.

Renoir sometimes showed a certain impatience with Vollard's writings on his work. These pieces have, however, remained among the liveliest sources on the artist, even though they should be taken with a pinch of salt. Renoir also agreed to the then-new experiment of making a catalogue with Vollard, or at least some kind of illustrated documentation of his work in his lifetime.

Vollard remembered that his first meeting with Renoir in 1894, soon after he began working as an art dealer, was when he came in to ask for information about a painting by Manet. He won the painter's trust, and their relationship lasted until Renoir's death. Vollard liked to have his portrait painted, and the list of artists who portrayed him is long indeed – Cézanne, Picasso and Bonnard are just a few. Renoir painted him not once but several times, notably in 1908 (above left) with the art dealer holding a statuette by Aristide Maillol. In the face of Vollard's entreaties Renoir tried his hand at sculpture, assisted by Richard Guino, a young man who had been Maillol's assistant. Together they created *Venus Victorious* (1914, above) and *Large Washerwoman* (opposite below) in 1917.

Yielding to Vollard's pressure, Renoir tried his hand at lithography and sculpture.

Bernheim-Jeune...

At the beginning of the 1890s, Josse and Gaston Bernheim-Jeune had become active in the gallery founded by their father, progressively giving more and more space to the Impressionists and the artists that followed them. The history of their commercial connection with Renoir, beginning with the important show of his work that they organized in 1900, is punctuated by portraits the artist made for the family in 1901 and 1910. Their connection was broken only by Renoir's death. Among their clients were two who had a particular interest in Renoir.

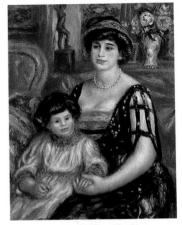

The wife of Josse Bernheim-Jeune and their son Henry (above) came to Les Collettes to be painted by Renoir in 1910.

...and their clients

The first, Maurice Gangnat, was an engineer. It seems that he bought his first Renoir painting at the Berard sale in 1905. He got to know the artist through Gallimard, becoming one of his rare intimate friends, and in less than twenty years he bought more than 150 works, which were dispersed at the public sale of his collection after his death.

The second, Louis-Alexandre Berthier, prince de Wagram, was a career soldier, as his family required, and a 'young prince collector of Impressionist painting and driver',

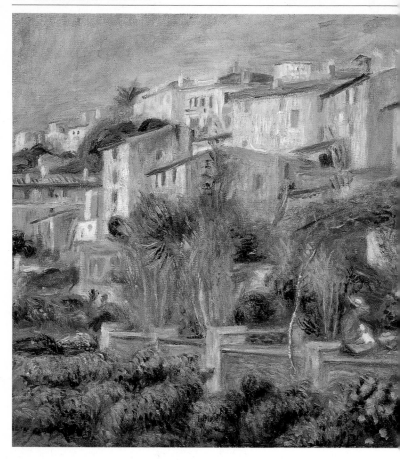

as the admiring Marcel Proust described him. Before his premature death in the final battles of the First World War, the young man would appreciably reduce his inheritance while pursuing his two passions: the automobile – paying damages in lawsuits brought against him by the owners of squashed dogs – and, even more expensive, Impressionist painting. In 1905 he started a frantic buying spree, going round all the Paris dealers and expending large sums. He soon decided he could speculate in painting and first associated himself

Between 1905 and 1910, Renoir represented the rows of roofs of old Cagnes many times, as in *Terrace in Cagnes* (1905, above). This was painted during one of his first visits to the Mediterranean village where he settled permanently at the end of his life.

with the Bernheim gallery and then started legal proceedings against it; the case was dismissed in the gallery's favour. In 1908 he began selling his collection – which included dozens of very important paintings by Renoir – at a loss.

Thanks to Durand-Ruel, Vollard, Bernheim-Jeune and their clients of various nationalities, Renoir was known throughout the world before 1900. While he suffered the gradual loss of his first patrons and friends, the dispersion of their collections only strengthened the commercial appeal of his work, which, like that of Degas and Monet, fetched high prices. Foreign museums also showed an interest. The Nationalgalerie in Berlin obtained *Children's Afternoon at Wargemont* in 1906, while the Metropolitan Museum of Art in New York acquired *Portrait of Madame Charpentier and her Children* in 1907.

The ageing Renoir

While Renoir finally had enough money to live very comfortably, his tastes remained simple, almost austere. During the winter, the rheumatism he suffered led him to seek out the climate of the south of France and he stayed at Magagnosc, near Grasse. In 1898 he discovered Cagnes-sur-Mer, near Nice, and its mild climate and beautiful landscape, along with his declining health, induced him to buy a property there in 1907, called Les Collettes. He built a house on it, which gradually became his main residence.

Renoir is shown painting at his easel around 1900 (below). This is one of the last photographs taken before illness compelled him to remain seated while working.

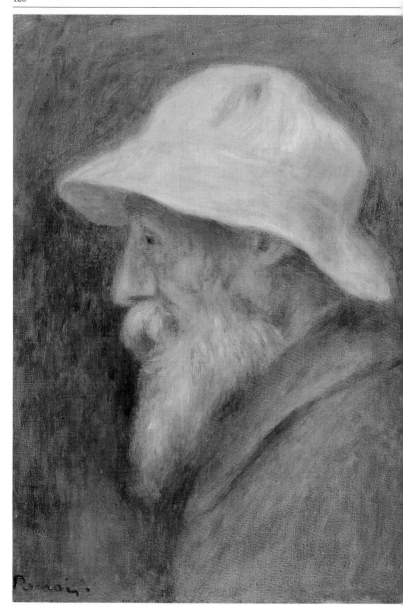

Now that I can no longer rely on my arms and legs, I would like to paint large canvases. I dream only of Veronese, of his *Marriage at Cana*. What misery!'

<div align="right">

Renoir
Letter to Albert André
Quoted in Albert André, *Renoir*, 1919

</div>

CHAPTER 6

RENOIR AT LES COLLETTES

There is not a trace of self-flattery in this image of an old man under his floppy hat that Renoir painted of himself in 1910. Referring to this man of modest appearance, the poet Guillaume Apollinaire wrote in 1913, 'Renoir continually grew greater. The most recent paintings are always the most beautiful. They are also the youngest.'

'A place in the French school'

The man who began to spend most of his time at Les Collettes was already an invalid. He travelled little. His last major trip was to Munich in 1910, where he stayed with Frau Franz Thurneyssen, Berard's niece, for whom he executed many portraits. Berard himself had died several years earlier.

However, he continued to spend time at Essoyes, and he retained a residence in Paris as well, on the Boulevard Rochechouart. Thus, he was able to accept the invitation of the well-known financier Alfred Edwards and his current wife, Misia (formerly married to Thadée Natanson), to attend one of the earliest performances of the Ballets Russes in Paris in 1911.

In the spring of 1919 – three months before his death – Renoir visited the Louvre, which turned out to be his last outing. He had been invited by Paul Léon, director of the Ecole des Beaux-Arts, to see the small *Portrait of Madame Georges Charpentier* that had recently come into the national collection and was on display. This was not the first work by Renoir to enter the Louvre; the paintings left by Isaac de Camondo had been there since 1914. Renoir thus lived to see one of his most heartfelt wishes realized: 'When I view the old masters, it makes me feel like quite a small man, yet I think that out of all my works, there are enough to assure me a place in the French school, that school that I love so much, that is so gentle, so clear, such good company…with nothing flashy about it.'

Renoir's influence

In the course of those years, Renoir's work has proved intensely influential. Exhibitions held before the First World War in France, at Durand-Ruel and Bernheim-Jeune, as well as in the United States, Germany, Italy and even Saint

The writer Elie Faure, who knew and admired Renoir in his last years, said that Picasso called the master 'the Pope'. The drawing below, which Picasso made after one of Renoir's early paintings, *Alfred Sisley and his Wife*, betokened a form of homage to the old painter. As for Matisse, he affirmed in 1918, 'After the work of Cézanne, whose tremendous influence is paramount among artists, Renoir's work saves us from the dryness of pure abstraction.'

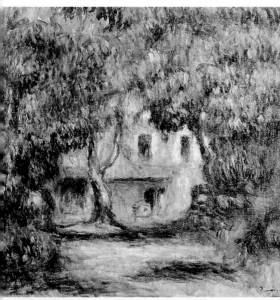

In June 1907 Renoir bought the estate called Les Collettes in Cagnes-sur-Mer, which had an old farmhouse (left in a painting of 1915). There he built a modern villa, large and comfortable. Mme Renoir, ever practical, planted orange trees, mandarin orange trees, and a kitchen garden. Among the hundred-year-old olive trees, Renoir built a large-windowed studio (below), from whose shelter he could continue to paint while having a sense of working outdoors, something he could no longer do because of his poor health. Although the isolation of Les Collettes offered some protection from people coming to seek him out, many pilgrims from as far away as Scandinavia and Japan started to show up, wanting to meet the old master.

After his father's death, Jean Renoir made many films at Les Collettes evoking the painter's world and work. In 1960 Renoir's house was bought by the town of Cagnes-sur-Mer and turned into a museum.

Petersburg displayed his most recent work as well as older canvases to a new generation.

The first illustrated monograph on the painter, by the German critic Julius Meier-Graefe, was published in German in 1911 and in French the next year. Many painters expressed their admiration for the old master, whether or not they made the pilgrimage to Les Collettes – among them Maurice Denis, Paul Signac, Pierre Bonnard, André Derain, Henri Matisse and Pablo Picasso.

The Barnes Foundation

On the other side of the Atlantic, in the Philadelphia suburb of Merion, Pennsylvania, lived Albert C. Barnes. Barnes had made his fortune with the development and commercialization of a powerful antiseptic, Argyrol. In 1912 he began to collect paintings, advised by his friend, the American painter William Glackens and a highly informed connoisseur, Leo Stein, who, with his sister Gertrude and their brother Michael, was one of the earliest collectors of Picasso and Matisse.

During his trips to Paris, Barnes bought works by Impressionists and Post-Impressionists, notably by Renoir and Cézanne, as well as by Matisse, Picasso, Soutine and Modigliani.

In order to silence the mockery these choices elicited, he decided to set up a foundation in 1922 to hold his collection, which would be used to educate the public. A sincere democrat, Barnes hoped to make art accessible

to everyone, particularly black American workers. At the same time, he limited access to his collections, indulging his resentment towards critics and art historians by excluding every single one of them.

For all of these reasons, until the 1990s – when many pieces from the collection were shown in museums around the world – the Barnes

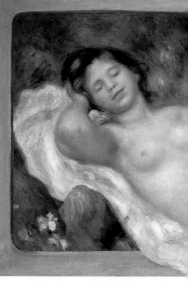

At the end of his life, Renoir confided to the painter Albert André that he had been drawn to sculpture. He also mentioned his admiration for Jean Goujon's reliefs, which seem to be the direct inspiration for *Reclining Nude (La Source)* (1895–7, above); the trompe l'oeil frame surrounding the painting reinforces the allusion.

●'I am convinced that I cannot get too many Renoirs,' Albert Barnes (left) wrote to Leo Stein in 1913, barely a year after purchasing his first works by the artist.

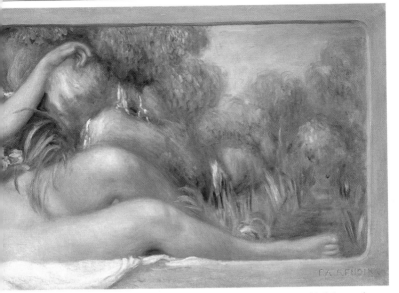

Foundation and its masterpieces retained a reputation as being mythic and inaccessible. It may be the only place in the world where next to 69 paintings by Cézanne and 60 by Matisse are 180 by Renoir, the earliest among them bought from the living artist. Dr Barnes never actually met the artist he so greatly admired; he was prevented from doing so first by the war and then by the painter's death.

B ehind the portals of the Barnes Foundation (below) is the richest collection of works by Renoir, Cézanne and Matisse in the world.

The end

Despite his advanced age and his illness, despite the death of his wife in 1915, and despite the war, in which two of his sons were wounded, the last ten years of the artist's life were fruitful.

Imprisoned in his chair and in pain, Renoir stopped walking around 1912 in order to marshal all his strength for painting. The life of the entire household, which his son Jean has evoked with nostalgia, revolved around his painting: The servants posed; easels that would allow him to paint large canvases were improvised, or he simply painted on small pieces of canvas tacked on to a support; brushes were slid into shrivelled hands that had been bandaged to prevent irritation. Such resolution impressed his contemporaries and gave rise to the morbid myth of the artist painting with brushes tied to his hands, a false impression that still cannot be dispelled.

It is best to leave out the rapid oil sketches that Renoir made purely as exercises; the artist's fame and a rising art market have combined to make them more important than they deserve to be. There remain enough finished paintings – portraits and nudes – to demonstrate the astounding scope of the old painter's mastery, deploying an exuberant palette of colours made

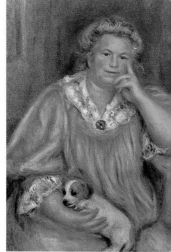

Aline Charigot rarely posed for the painter after the 1880s, once she had become Mme Renoir. At the time of the portrait with the dog Bob (above), painted in 1910, she had just reached the age of fifty but, like Renoir, she looked older.

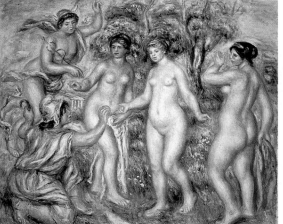

The exuberant *Judgment of Paris* (left), painted about 1913–4, is linked by means of its mythological theme with the Dianas and Venuses of Renoir's early paintings. The painting's origins are in a plaster relief and the sculpture *Venus Victorious*. Renoir's model Gabrielle can be recognized on the extreme right.

deliberately more intense because he was afraid that the carmine, yellows heightened with green, and deep blues would fade with time.

'I think I'm beginning to understand something about this'

In working on his favourite themes, Renoir, no doubt inspired by the Mediterranean light, rediscovered classical mythology: Venus, the shepherd Paris, Neptune, nymphs. But it is important not to place too much emphasis on the subject. The artist said, 'The nude woman emerges from the sea or her bed. Whether we call her Venus or Nini, we cannot invent anything better. Whatever gives me the excuse to group a few figures is all I need. Not too much literature, not too many thinking figures.'

Pierre-Auguste Renoir died on 3 December 1919 at Les Collettes. He had taken to his bed with a pulmonary infection. According to his son Jean, a few hours earlier, the painter had asked for his palette and paintbrush in order to paint some flowers. As he handed them back to his nurse, he murmured, 'I think I'm beginning to understand something about this.'

• Painting was intended to decorate walls, wasn't it? Therefore it should be as rich as possible. For me a painting…should be something to cherish, joyous and pretty, yes, pretty! •
 Renoir to Albert André

The Bathers (The Great Bathers) (1918–9, below) constitutes Renoir's pictorial legacy. It once again takes up the theme of the nude in a landscape: 'My landscape is only a prop,' Renoir confided to a visitor in 1918. 'When I'm painting it I'm trying to fuse it with my figures.'

Overleaf: Renoir painting in Cagnes, c. 1903–7.

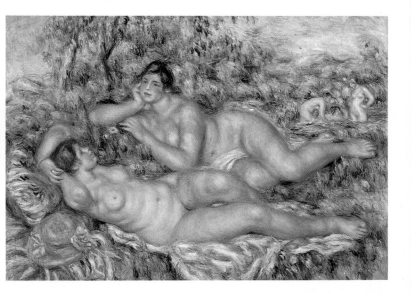

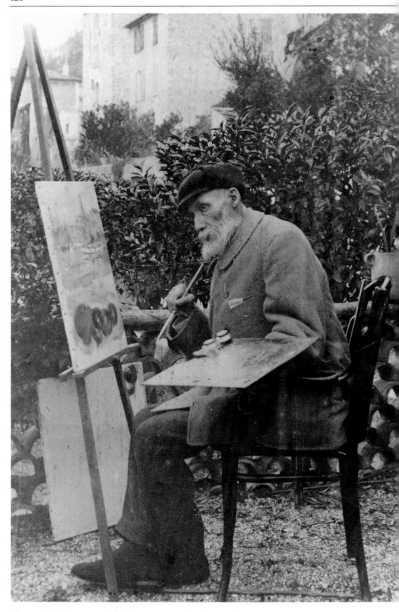

DOCUMENTS

Letters

Renoir was not highly educated; he wrote in a style that expressed his lively personality and communicated his artistic concerns with humour or feeling. His letters, full of spelling mistakes, accurately reflect the person who wrote them.

A letter from Renoir to Georges Charpentier, 29 January 1882.

Mon cher ami

Je déjeune ce matin Lundi avec votre ami Frick. Je reste une quinzaine Hotel des Bains à L'Estaque et je rentre vous serre la main.

Mille amitiés a Madame Charpentier.

a vous

Renoir

Marseille 29 Janvier 82.

P.S. Il fait un temps Superbe

To Bazille: household worries

At the beginning of 1868, Renoir moved in with Bazille at 9 Rue de la Paix aux Batignolles (renamed Rue de La Condamine at the end of 1868), where they shared a studio. That summer Renoir wrote to Bazille, who was in the south of France on holiday at his parents' home.

My dear friend, I've just come from Les Batignolles, and I read your letter. Here are the measurements of the windows: four metres high by three metres wide; therefore you need to have four curtains four metres high by two metres wide made up, taking the pleats into account. You'd do well to write to Hardy immediately, to whom I sent the notices of the Salon about a week ago, and I haven't yet seen your paintings in the studio, which makes me worry about the letter that I addressed to 36 Rue du Cherche-Midi. You know I have a small account to settle with him, which makes it impossible for me to write to him myself. I can't find the pawn ticket for your watch; tell me exactly where it is. I'm in Ville-d'Avray and rarely come to Les Batignolles, and then only to fetch some things. So that I can do what you want me to do and if you have some money, you'd best send it to me right away, just so you won't use it all up. You don't need to worry about me, seeing as I have neither wife nor child and I'm far from ready to have either one. Drop me a note to let me know if I should see to the carpentry work immediately, which would put me out considerably, since first of all I'm working, plus I don't always have enough to eat in Paris and here I do very well. I'll write a longer letter another time, since I'm hungry and I have a plate of brill in white sauce in front of me. I'm not putting a stamp

on [this letter] since I have only twelve sous in my pocket, and that's for going to Paris when I have to.

In Gaston Poulain
Bazille et ses Amis, 1932

To the Charpentiers: money and style

The following two letters were written to the artist's patrons Georges and Marguerite Charpentier around 1878–80.

My dear friend,

I will ask you, if it's in the realm of possibility, for the sum of three hundred francs before the end of the month, if that's possible, I am very sorry, it is the last time, and I will no longer have to write you anything but banal, completely silly letters without asking you for anything, because you will no longer owe me anything except respect, since I am older than you. I am not sending you my bill because I don't have any.

Now, my dear friend, be kind enough to thank Mme Charpentier very much on behalf of her most devoted artist, and tell her that I will never forget that if one day I finally make it, I will owe it to her because I certainly am not capable of doing it on my own. I would like to be there already the sooner to express to her all my gratitude.

Friend Renoir
In Barbara Ehrlich White
Renoir: His Life, Art, and Letters, trans.
John Shepley with
Claude Choquet, 1984

Dear Madame

I want to tell you about an idea of Mme Berard's that in my opinion is not entirely senseless. It is to put the week's fashion on the last page of *La Vie moderne.*

I would undertake to do the draw-

ings, very accurately, as soon as I get back to Paris. In this way, you will have on your side the whole female staff, who would not always be interested in sketches by [Jean-Louis] Meissonnier [*sic*] or others.

An arrangement could be made with milliners and dressmakers. One week of hats, another of dresses, etc.… I will go to them to do the drawings, from life, from different sides. There's an idea. I'm conveying it to you for what it's worth.

Best regards,
Renoir
In Barbara Ehrlich White
Renoir: His Life, Art, and Letters, trans.
John Shepley with
Claude Choquet, 1984

To Duret: a thwarted trip

The critic and collector Théodore Duret made Renoir's acquaintance early on. This letter was written on Easter Monday, 1881.

My dear Duret,

I'm very embarrassed to tell you why I put off my trip to London. I've just seen Whistler, he was very charming, he came to lunch with me at Chatou, and I am really happy to have spent a few moments with this great artist. I tell you all this because were it not for you I would never have dared to speak to him, for I began by mentioning to him your article in the magazine.

Tomorrow I'll lunch with him and I have given him the job of explaining to you the thousand reasons that force me to put off my trip, perhaps to next year. I am struggling with the trees in flower, with women and children, and I have no desire to look at anything else. Still, I'm constantly having regrets. I think of the trouble I caused you for nothing and I ask myself if you will swallow my fickle

whims, meanwhile, the whole affair makes me anticipate glimpses of those pretty English women. What a terrible thing it is to be so indecisive, but it's fundamental to my nature and I'm afraid that as I age I will not be able to change. The weather is wonderful and I have models: there, that's my only excuse.

I will have the portraits of the young Cahens [see p. 67] at the Salon. I don't know if they will bring the same awful result as my show last year. I hope not.

Whistler told me he left London abruptly and without letting you know[;] he asked me to give you his excuses; he maintains that if he hadn't taken this step, he would not have left, that's true enough.

I will write again soon,

<div align="right">Friend
Renoir
In Michel Florisoone
'Renoir et la Famille Charpentier'
L'Amour de l'Art, February 1938</div>

To Durand-Ruel: why send paintings to the Salon?

Renoir left for northern Africa in 1881 after preparing the paintings he was going to send to the official Salon. He felt it necessary to explain his thinking about the Salon to his dealer Paul Durand-Ruel in this letter from Algiers in March.

My dear Monsieur Durand-Ruel,
I shall now try to explain why I am sending to the Salon. There are in Paris barely fifteen collectors capable of appreciating a painter unless he has exhibited at the Salon. There are eighty thousand who will not buy even a nose if a painter is not in the Salon. That is why I send two portraits each year, little though that is. Furthermore, I am not going to fall into the obsessive belief that something is bad just because of where it is. In a word, I don't want to waste my time resenting the Salon. I don't even want to seem to do so. I believe a painter should produce the best painting possible.… That is all. Now if people accused me of neglecting my art, or making sacrifices which go against my own ideas of an idiotic sense of ambition, then I would understand the criticism. But since this is not the case, I cannot be criticized in this way, quite the contrary. All I am concerned with at this moment, as always, is making good things. I want to make you splendid paintings which you will be able to sell for very high prices. I shall soon manage to do this, I hope. I have stayed in the sun, away from all painters, to reflect at length. I think I have reached my aim, and have found what I am looking for. I may be wrong, but it would greatly surprise me. A little more patience and soon I hope to give you the proof that one can send work to the Salon *and* do good paintings.

I therefore beg you to plead my case with my friends. The fact that I am sending work to the Salon is purely a matter of business. In any case, it's like certain medicines. If it does no good, at least it does no harm.

I think I have recovered my health. I shall be able to work solidly and make up for lost time.

Which reminds me, I wish you good health. And a lot of rich collectors. But keep them for my return. I shall be here for another month. I don't want to leave Algiers without bringing back something of this marvelous country. Fondest wishes to our friends and yourself,

<div align="right">Renoir
In Renoir: A Retrospective,
ed. Nicholas Wadley, 1987</div>

To Charles Deudon: goodbye, Venice

Renoir left for Italy in the autumn of 1881.

Dear Friend,

Goodbye Veni-i-ce, its lovely grey skies,

Land of promi-i-se, a true pa-ra-dise. I'm off to Rome and next to Naples. I want to see the Raphaels, yessiree, the-Ra, the-pha, the-els. After that, those who won't be satisfied.... I bet they'll say I've been influenced!

I'm sending two awful studies to Paris that will arrive in a fortnight, because I gave them to an art-supply dealer to send when they're dry. I'm sending them to Rue Saint-Georges, you tell me if they remind you of Venice. I've done the Doges' Palace seen from San Giorgio across [the canal], that had never been done before, I think. We were at least six in single file.

Best wishes.

Renoir

In Marcel Schneider 'Lettres de Renoir sur l'Italie', *L'Age d'Or*, I, October 1945

To Paul Berard: Italy forever

It is truly ravishing; the water is wonderful with its reflections of houses. ... I am in love with the sun and its reflections in the water, and to paint them I'd go around the world. But when I'm working on it, I feel my impotence. ... Why bother looking for the sun, since all that I've done doesn't even come close; *he will console himself by going to museums, but* it's nothing next to nature, those great masters come out looking grey and melancholy. It's futile for me to seek out the light, I'll end up like them, black, always black. Sculptors are lucky dogs, their statues stand in the sun, and when they are of pure form, they become part of the light, they live in nature like a tree[;] us, we are doomed to interiors or else we fade after a few days, like wilted flowers. Why did I become a painter since I am reduced to admiring without ever imitating, except from such a distance....

Renoir will bring back by way of information a study where I piled chrome yellow on top of bright yellow. You'll see how bad it is. I looked for women, the first day full of enthusiasm, but on the second day I saw that these Auvergne people were horrible. Ah! Paris, with its pretty ladies' hats, with its life. It's a sun that can be represented, why did I leave it?

From sale catalogue of autographs and manuscripts, Drouot-Rive Gauche, Paris, 16 February 1979

To Durand-Ruel: 'I'm still feverishly searching'

Renoir wrote to his dealer again on 21 November 1881 from Naples.

Dear Monsieur Durand-Ruel,

I've been wanting to write to you for a while but I also wanted to send you a

A letter from Renoir to Paul Durand-Ruel, July 1885.

bunch of canvases. But I'm still fever-
ishly searching. I am not satisfied, and
I scrape and scrape again. I hope this
fever will lift, that's why I'm writing to
you with my news. I don't think I'll have
much to bring back from my trip. But
I think I've made progress, which always
happens after a long period of search-
ing. We always return to our first loves,
but with something extra. Meanwhile,
I hope you will forgive me for not
having much to show you. But you will
see what I will do for you in Paris.

I'm like a schoolboy. The white page
should always be neatly written on and
boom! a blot. I'm still making blots…
and I am forty years old. I have seen the
Raphaels in Rome. They are very beau-
tiful and I should have seen them before.
They are full of knowledge and wisdom.
He did not try to do impossible things,
like me. But they're beautiful. I prefer
Ingres for oil painting. But the frescoes,
they are admirable in their simplicity
and nobility.

I imagine you are well, and your little
family also. But I will see you soon, for
Italy is very beautiful. But Paris…Ah!
Paris… I am starting on something. I
won't tell you what. I would ruin it.
I'm superstitious.

All good wishes,
Renoir
In Lionello Venturi
Les Archives de l'Impressionnisme, 1930

At Palermo: a historic encounter with Richard Wagner

*To an unidentified 'Wagnerian friend',
Renoir gave an account of his meeting
with the composer. The letter is dated
14 January 1882.*

My dear friend,
I am very worried about my letter,
because after sealing it, I weighed it,
uncertain whether to put two stamps.
But since I mailed several letters at
the same time, I may have put it in
another one. Where the hell did it go?
Fortunately I have a torn draft of it,
so I'm going to try to recopy it as it is,
without even asking your indulgence.
You know very well that I can't write.
That's it, phew!

After having resisted my brother
for a long time, he sends me a letter of
introduction to Naples, from M. de
Brayer. I don't read the letter and above
all I don't look at the signature, and
there I am on the boat with the prospect
of being seasick for at least fifteen hours.
It occurs to me to look in my pockets,
no letter, I probably forgot it at my
hotel, I go through everything on
that boat, impossible to lay my hand
on it, you see my predicament when
I get to Palermo. I find the city sad and
I wonder whether I shouldn't take the
boat back in the evening. Finally I walk
sadly to an omnibus on which is written:
Hôtel de France. I go to the post office
to find where Wagner is staying; nobody
speaks French and nobody knows who
Wagner is, but at my hotel, where there
are some Germans, I finally learn that
he is at the Hôtel des Palmes. I take a
carriage and go to visit Monreale where
there are fine mosaics, and on the way I
abandon myself to a lot of sad thoughts.
Before leaving, I send a cable to Naples,
without any hope by the way, and
I wait; not seeing anything coming,
I decide to introduce myself alone, and
so there I am, writing a letter in which I
ask to pay my respects to the master, my
letter ended more or less like this: I will
be happy to take news of you back to
Paris, especially to M. Lascoux, to Mme
Mendès, I can't put to M. de Brayer,

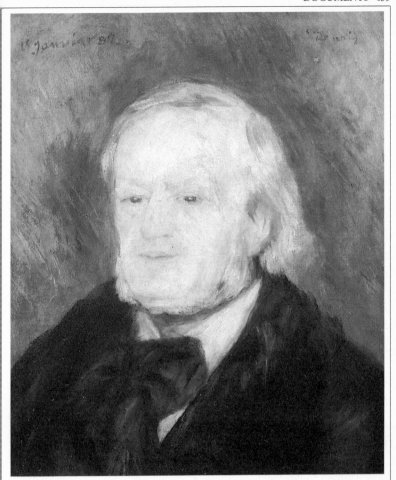

R*ichard Wagner,* 1882, resembling a Protestant minister.

because I hadn't looked at the signature on my letter of introduction. Here I am at the Hôtel des Palmes; a servant takes my letter, comes back down after a few minutes, telling me in Italian: *Non salue* [*sic*] *il maestro,* and he walks away. Next day I receive my letter from Naples, and I present myself again to that same servant, who this time takes my letter from me with obvious scorn. I wait under the carriage entrance, hiding myself as much as possible, not in the

mood to be received, because I only brought myself to this second attempt in order to prove to this family that I hadn't come to beg them for 40 sous.

Finally along comes a blond young man whom I take for an Englishman, but he's Russian and his name is Joukovski. He ends up finding me in my corner and takes me into a little room. He says he knows my work very well, that Mme Wagner is very sorry not to be able to receive me now, and he asks me if I could stay one more day in Palermo, because Wagner is putting the final notes to Parsifal and he is in a state of illness and nerves, and no longer eats, and so on.

I beg him to give my apologies to Mme Wagner, but I ask only one thing, and that's to leave. We spend some time together and I tell him the purpose of my visit. I see by his smile that it's a failure, then he confesses to me that he is a painter, that he too would like to do a portrait of the master and that for two years he has been following him every-where in order to fulfill this desire, but he advises me to stay, saying: what he denies me he may grant to you, and anyway you can't go away without seeing Wagner. This Russian man is charming, he ends up consoling me and we make an appointment for the next day at two o'clock. Next day I meet him at the telegraph office. He tells me that yester-day, February [sic] 13, Wagner completed his opera, that he is very tired and that I shouldn't come before five o'clock, that he will be there so that I won't be so ill at ease, I accept enthusiastically and go away happy. I'm there at five o'clock sharp, and I run into my servant who greets me with a deep bow, asks me to follow him, and he takes me through a little greenhouse, then into a small

adjoining sitting room, sits me down in a huge armchair, and with a gracious smile asks me to wait a moment. I see Mlle Wagner and a small young man who must be a little Wagner, but no Russian. Mlle Wagner tells me that her mother is not there, but that her father is coming, and then she takes off. I hear a sound of footsteps muffled by thick carpets. It's the master, in his velvet dressing gown, the wide sleeves lined with black satin. He is very handsome and very courteous, and he shakes my hand, urges me to sit down again, and then the most absurd conversation begins, strewn with uhs and ohs, half French, half German with guttural endings.

I am very gontent. Ach! Oh! and a guttural sound, you are coming from Paris. No, I am coming from Naples, and I tell him about losing my letter, which makes him laugh a lot. We talk about everything. When I say we, I only kept repeating: My dear master, of course, my dear master, and I would get up to leave, and then he would take my hands and put me back in my armchair. Vait a little more, my vife vill be coming, and that goot Lascoux, chow is he? I tell him that I haven't seen him, that I have been in Italy for a long time and he doesn't even know I'm here. Ach! Oh! and a guttural sound in German. We talk about Tannhäuser at the Opéra, in short it goes on for at least three-quarters of an hour, and meanwhile I keep looking to see if the Russian has arrived. Finally he comes in with Mme Wagner, who asks me if I know M. de Brayer well. I raise my head. M. de Brayer, heavens no, madame, not at all, is he a musician? So then he is not the one who gave you this letter.

Oh, de Brayé, yes, very well, excuse me, we do not pronounce it the same,

and I apologize, blushing. But I make up for it with Lascoux, I imitated his voice to show her that I knew him, then she told me to give their regards to their friends when I got back to Paris, and especially to Lascoux, she insisted on it; she repeated it again when I left. We talked about the Impressionists of music. How many foolish things I must have said! I ended up roasting, being completely giddy and red as a rooster. In short, the timid man who plunges in, and goes too far, and yet I know that he was very pleased with me, I don't know why. He detests the German Jews, and among others [the critic Albert] Wolff. He asked me whether we still like [Meyerbeer's] Les Diamants de la Couronne in France. I panned Meyerbeer. In the end I had time enough to say all the silly things you can imagine. Then all of a sudden he said to M. Joukovski, if I'm feeling all right at noon, I may let you have a sitting until lunch, you know you'll have to be understanding, but I will do what I can, if it doesn't last very long it won't be my fault. M. Renoir, please ask M. Joukovski if it's all right with him if you do me too, if that doesn't bother him. Joukovski says: But, my dear master, I was just about to ask you, etc., etc.... How would you like to do it? I say, full face. He says to me that's fine, I want to do your back, because I have a composition all ready. Then Wagner says to him, you will do me turning my back on France and M. Renoir will do me from the other side. Ach! Ach! Oh!...

Next day I was there at noon, you know the rest. He was very cheerful, but [I was] very nervous and sorry not to be Ingres. In short, I think my time was well spent, 35 minutes, which is not much, but if I had stopped sooner, it would have been excellent, because my model ended by losing a little of his cheerfulness and getting stiff. I followed these changes too much, anyway you'll see.

At the end Wagner asked to look, and he said Ach! Ach! I look like a Protestant minister – which is true. Anyway I was very glad not to have failed too badly: there is a little souvenir of that splendid head.

Best.

Renoir

I'm not rereading my letter, I would tear it up again and it would be the fifteenth. If there are things I forgot, I will tell them to you.

He repeated several times that the French read the art critics too much. The art critics, Ach! Ach! and a big laugh. The German Jews!, but, M. Renoir, I know that in France there are good guys whom I do not confuse with the German Jews. Unfortunately I'm unable to convey the openness and gaiety of this whole conversation of the master's.

In Barbara Ehrlich White
Renoir: His Life, Art, and Letters, trans.
John Shepley with
Claude Choquet, 1984

To Mme Charpentier: on the sun in painting

On returning from Italy, Renoir made a confession to Marguerite Charpentier towards the end of January or the beginning of February 1882.

Dear Madame,

I got a letter from [Charles] Deudon at Naples that said that you had spoken of me often which gave me real pleasure, and in addition that you were waiting expectantly for the pastel of your little girl.

Marguerite Charpentier.

I would have had to rush to Paris and I have not done it because I am in the middle of learning a great deal and the longer I take, the better the portrait will be.... I have constant sun [here] and I can scrape off and begin again as much as I want. That's the only way to learn, and in Paris one must make do with a little [sun]; I've spent a lot of time at the Naples museum, the paintings from Pompeii are extremely interesting from all points of view, I also stay in the sun, not to make portraits in the sunshine, but by warming myself and looking around a lot I think I will have arrived at that grandeur and simplicity of the old masters. Raphael who did not work outdoors nevertheless must have studied the sun, as it fills his frescoes. Thus by dint of looking outdoors I got to the point where I see only the larger harmonies without getting lost in the small details that blot out the sun instead of setting it on fire. Therefore I hope on returning to Paris to do something that would show the results of these general studies, and you will

benefit from it. I could be deluding myself, as you might well think, but I have done whatever I could to prevent that. Humans were made to fool themselves. Please excuse me.

Best regards, and a firm handshake for Monsieur Charpentier.

Renoir
In Michel Florisoone, 'Renoir et la Famille Charpentier', February 1938

'Independent' despite himself

On his return from Italy, Renoir became troubled by Durand-Ruel's plans to enter his paintings in an Impressionist exhibition. He registered his opposition in a letter to his dealer.

L'Estaque, 26 February 1882
My dear Monsieur Durand-Ruel,
...This morning I sent you a telegram as follows: The paintings of mine that you have are your property. I cannot prevent you from disposing of them, but it will not be me who is exhibiting.

These few words express my thought completely.

It is therefore quite clear that I am not having any part of the Pissarro-Gauguin group and that I do not agree to be included in the so-called group of Independents for a single moment.

The first reason is that I am exhibiting at the Salon, which does not fit in with the rest.

Therefore I refuse, and refuse again.

Now you may put in the canvases that you have, without my permission. They are yours, and I do not claim the right to prevent you from disposing of them as you see fit, if it is in your own name. Only let it be clearly agreed and accepted that it is you who, as the owner of canvases signed with my name, are exhibiting them, and not me.

P aul Durand-Ruel's large drawing room.

In these conditions the catalog, posters, brochures and other information to the public shall state that my canvases are the property of…and exhibited by M. Durand-Ruel.

In this way, I shall not be an 'independent' despite myself, if I am not allowed not to be an 'independent' at all. Please do not resent this decision which should scarcely affect you personally, since it is not you who is organizing this exhibition, but M. Gauguin, and believe me your ever devoted and faithful artist. Only, I am protecting our common interest, for I believe that to exhibit there would be to devalue my canvases by 50%. I repeat once more, nothing in my refusal should wound you, for nothing is addressed to you and everything to the gentlemen alongside whom I do not wish to find myself, for my own good, because of my own taste, and in your own interest.

I send you my sincere wishes for your good health and a warm-hearted assurance of my friendship, Renoir.

Trans. in *Renoir: A Retrospective*,
ed. Nicholas Wadley, 1987

When hands can no longer write

Cagnes, 27 February 1919
My dear Durand-Ruel [his dealer],
I was very moved that you took the trouble to write to me yourself, given the pain it costs you. That shows me how much affection you have for me, and please believe that I am very grateful.

Please accept, my dear Durand-Ruel, all my sympathy.

Renoir

P.S. You were able to write to me, but I cannot respond in kind. That is impossible for me.
In Lionello Venturi, *Les Archives de l'Impressionnisme*, 1930

The painter in his own words

Renoir's contemporaries were entertained by the originality of his language. Some of them collected his sayings and jests, often colouring them with their own personalities. Even so, the tone remains true: it is definitely Renoir speaking. Albert André and Jean Renoir were probably the most faithful transcribers.

B onnard took this photograph of Auguste Renoir with his son Jean in 1916.

As told to André

Fascinated by Renoir, the painter Albert André was an attentive listener. He made an excellent collection of the painter's offhand comments in the studio.

I made that poor Gleyre crazy way back when, in the studio. He came once a week. He stopped in front of my easel.… It was my first week there. I had set myself to copying the model as best I could.

Gleyre looked at my canvas, assumed a stern air, and said, 'No doubt you paint to amuse yourself?'

'But of course,' I answered, 'and if it didn't amuse me, I assure you I wouldn't do it!'

I am not sure that he understood me.

'The essence of Renoir is revealed in his answer to Gleyre. He painted because it deeply amused him,' commented Albert André. 'He never believed that by putting pigments on the canvas he was fulfilling a religious mission or, as he laughingly put it, that he was saving the Republic.'

Painting was intended, was it not, to decorate walls. Therefore it should be as rich as possible. For me a painting, since we are forced to make easel paintings, should be something to cherish, joyous and pretty, yes, pretty!

There are enough annoying things in life without our creating new ones.

I well know how hard it is to accept that a painting could be a great painting and still be joyous. Because Fragonard laughed, people were quick to say he was a minor painter.

People who laugh are not taken seriously. Art that dresses the part, whether in painting, music or literature, will always get the attention.

You shouldn't think too much of yourself ...but it's also bad to think yourself worse than everyone else. You should know yourself, know your worth.

When I view the old masters, it makes me feel like quite a small man, yet I think that out of all my works, enough of them will assure me a place in the French school, that school that I love so much, that is so gentle, so clear, such good company...with nothing flashy about it.

I have always abandoned myself to fate, I never had a fighter's temperament and I would have given up many times over had not my good friend Monet, who had it himself – a fighter's temperament – bucked me up.

Today, when I look back at my life, I compare it with one of those corks thrown in the water. It spins, then it's taken by an eddy, pops up again behind it, dives, resurfaces, is caught by a weed, makes desperate attempts to free itself and finally disappears, God knows where....

Aphorisms on art

Jean Renoir found his father's notes, which he transcribed in his book about him. These self-contained thoughts are the elements of the 'Grammar of the Arts' that Renoir dreamed of putting in published form for the benefit of young artists.

Everything that I call grammar on primary notions of Art can be summed up in one word: Irregularity.

The earth is not round. An orange is not round. Not one section of it has the same form or weight as another. If you divide it into quarters, you will not find in a single quarter the same number of pips as in any of the other three; nor will any of the pips be exactly alike.

If art is superfluous, why caricature or make a pretense of it?... I only wish to be comfortable? Therefore I have furniture made of rough wood for myself, and a house without ornament or decoration.... I only want what is strictly necessary.... If I could obtain that result I should be a man of taste. But the ideal of simplicity is almost impossible to achieve.

The art lover is the one who should be taught. He is the one to whom medals should be given – and not to the artist, who doesn't care a hang about them.

Go and see what others have produced, but never copy anything except nature. You would be trying to enter into a temperament that is not yours and nothing that you would do would have any character.

Jean Renoir
Renoir, My Father, trans. Randolph and Dorothy Weaver, 1958

Renoir and Albert André in 1906.

In the studio

Rags on the floor, some white wooden chairs, easels, brushes, oil paints… At first glance, the decor of creation disappointed the uninitiated. But once visitors were admitted into this intimate space of the painter, once they saw him at work among his canvases and his models, they were won over.

A seated nude bather drawn in red chalk from c. 1885–90.

Renoir before his easel

Thanks to the painter Albert André, who knew Renoir well towards the end of his life, we can enter his studio at Les Collettes. Before he died, Renoir was able to read the book his young friend wrote about him, published in 1919, and express his gratitude.

His studios, whether in Paris or in the country, are empty of any furniture that might encourage visitors to stay for long. A broken down divan, covered in clothes and old flowered hats for his models; a few chairs that are always cluttered with canvases. But for the eyes there is a riot of color, an Aladdin's cave: finished paintings, waiting to dry, and canvases that are still being worked on. They are all tacked on the wall or lying about the floor, with no thought of presentation. If by chance there is a painting that is framed and hung in a presentable way, it will have been done for, and by, someone else in the Renoir circle.

He wears no special painter's garb. He sits in his armchair, his spindly legs crossed; his poor feet clad in woolen slippers; his body wrapped in shawls; his pale, fine head muffled to the ears in a cap, or a white linen hat according to the season; and in his fingers the ever-present cigarette, which he constantly relights.

He welcomes friends joyfully. But if he suspects that anyone has come to see him out of curiosity, he withdraws into himself, says nothing and becomes totally disagreeable. As soon as he has rid himself of such unwelcome visitors, and is back in front of his easels, he is a man transformed. He whistles, hums the tunes which his models so often sing to him and goes into ecstasies over the beauties which only his eye can find in them.

It is only really in such moments that

he may be persuaded to divulge his theory of art in all its simplicity.

This man, who has put painting above all else in his life, speaks very little of the painting he has done.

'Just look at the light on the olive trees.… It glitters like a diamond. It's pink, it's blue.… And the sky coming through them. It's enough to drive you crazy. And those mountains over there which change with the clouds.… They're like the background in a Watteau.'

'Ah! this breast! How very soft and heavy it is! That pretty fold underneath with its golden color.… It's enough to bring you to your knees. If there had never been any breasts, I don't think I should ever have painted figures.'

<div style="text-align: right">Albert André
Renoir, 1919, trans. in Renoir: A Retrospective, ed. Nicholas Wadley, 1987</div>

From the sketch to the finished painting

When starting on a complicated composition, he doesn't make what you would really call a study. Once his motif is decided on, he does some little paintings in the spirit of the subject. Sometimes it is a single figure, sometimes several. This process is a sort of practice for the definitive work. When it is fixed in his mind, he next draws his composition in sanguine, and traces it on to his canvas.

Drawing with a hard pencil doesn't suit him, even though he has done some admirable studies in that medium. He needs something that is softer than the pencil, and more colorful, in order to realize large masses. His preference is for charcoal or for a brown-red pastel.

He can no longer change brushes while he's working. Once the brush is selected, and strapped between his paralyzed fingers, it travels from the canvas to his pot of turps to be cleaned, back to the palette to be recharged, and then returns to the canvas.

When his hand becomes numb with exhaustion, someone has to retrieve the brush from his fingers, since they cannot open by themselves. He asks for a cigarette, rolls back his wheelchair, screws up an eye, gives a dissatisfied grunt or a modest expression of praise before getting back to work.

'How difficult it is in a picture to find the exact point at which to stop copying nature. The painting must not smell too strongly of the model, but at the same time, you must get the feeling of nature. A painting is not a verbatim record. For myself, I like the sort of painting which makes me want to stroll into it if it's a landscape, or if it's a female figure, to run my hand over a breast or back. Corot has some very coarse ways of describing what I mean.'

<div style="text-align: right">Albert André
Renoir, 1919, trans. in Renoir: A Retrospective, ed. Nicholas Wadley, 1987</div>

Renoir and his models

'The model is only there to set me going,' he says. 'She enables me to dare things that I couldn't invent without her, also to help me back on course if I go too far.' So he always likes to have a model in the house, on a permanent basis.

He has a taste for heavy hands and feet. The beautiful, robust girls who have served, almost exclusively, as his models during his last twenty years, have been his youngest children's nurse-maids.

Almost all of his figures reveal this single type of feminine beauty that he favored most. The mouth coming forward as if for a kiss; the bright, joyful eyes; the long torsos with exaggerated

hips; the slightly short legs, rounded but not particularly muscular; the feeling of bonelessness. This type becomes more emphatic around 1880; he finds it all around him and imparts it, despite himself, to all of his figures.

A new model disturbs him, holds him back a little. He doesn't feel relaxed enough to work, but often he dares not send her away. Without a word, he gets on with painting a rose in the corner of his canvas, or some clothes draped over a chair, while the girl – quite unaware of her irrelevance – continues to pose.

Albert André
Renoir, 1919, trans. in *Renoir: A Retrospective*, ed. Nicholas Wadley, 1987

Jean Renoir in the studio

The second privileged witness is Jean Renoir.

Renoir began by putting incomprehensible little touches on the white background, without even a suggestion of form. At times the paint, diluted with linseed oil and turpentine, was so liquid that it ran down the canvas. Renoir called it 'juice'. Thanks to the juice, he could, with several brushstrokes, establish the general tonality he was trying for. It covered almost the whole surface of the canvas – or rather, the surface of the eventual picture, for Renoir often left part of the background blank. These open spots represented indispensable values to him. The background had to be very clear and smooth. I often prepared my father's canvases with flake-white mixed with one third linseed oil and two thirds turpentine. It was then left to dry for several days.

But to return to the actual execution of the picture. He would begin with little pink or blue strokes, which would then be intermingled with burnt sienna, all perfectly balanced. As a rule Naples yellow and madder red were applied in the later stages. Ivory black came last of all. He never proceeded by direct or angular strokes. His method was round, so to speak, and in curves, as if he were following the contour of a young breast. 'There is no such thing as a straight line in nature.' At no time was there any sign of imbalance. From the first brushstroke the canvas remained in perfect equilibrium. Renoir's problem was, perhaps, to penetrate his subject without losing the freshness of the first impact. Finally, out of the mist the body of the model or the outlines of a landscape would emerge, as on a photographic plate immersed in a developing bath. Certain features totally neglected in the beginning took on their proper importance.

He succeeded in taking complete possession of his subject only after a struggle. When painting, he sometimes made you think he was fighting a duel. The painter seemed to be eyeing the movements of his opponent and watching for the last weakness in his defenses. He harassed the subject ceaselessly as a lover harassed the girl who puts up a struggle before yielding. He seemed also be to engaged on a hunt. The anxious rapidity of his brushstrokes, which were urgent, precise, flashing extensions of his piercing vision, made me think of the zigzag flight of a swallow catching insects. I purposely borrow a comparison from ornithology. Renoir's brush was linked to his visual perceptions as directly as the swallow's beak is linked to its eyes.

Jean Renoir
Renoir, My Father, 1958

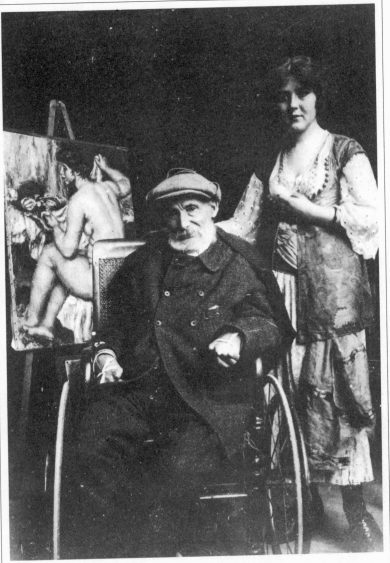

Auguste Renoir and his model Catherine Hessling in the studio at Les Collettes in 1918.

As seen by others

Always indecisive and subject to sudden depressions, Renoir was restless. His nervousness contrasted with the serenity of his painting, which betrayed neither effort nor conflict. The energy that he continued to pour into his painting even after he became old and disabled won his contemporaries' admiration.

Renoir in his studio at Les Collettes in 1910.

A brief portrait

Edmond Renoir, journalist and brother of the artist, put his pen at the service of the Impressionists. He wrote this portrait for the periodical published by Georges Charpentier.

I promised you a twenty-line portrait: rapt, absorbed, somber, remote, you have seen him rushing across the boulevard dozens of times; forgetful, disorderly, he will come back ten times for the same thing and still forget to do it; always running in the street, always motionless indoors, he will spend hours without moving, without speaking; what is he thinking of? Of the painting he is doing or about to do; he speaks about painting only as little as possible. But if you want to see his face light up, if you want to hear him – oh the wonder of it – humming some gay tune, don't look for him at table, or in places where one normally seeks amusement, but try to catch him unawares while he is working.

Edmond Renoir,
'Cinquième Exposition de la Vie Moderne', *La Vie Moderne*, 19 June 1879, trans. in *Renoir: A Retrospective*, ed. Nicholas Wadley, 1987

A dinner at the Charpentiers

Once when my father was out painting in the Forest of Marly he suddenly remembered an invitation for that evening to a large dinner party at the Charpentiers'. He was to be introduced to [Premier Léon] Gambetta, who was then at the height of his power. Charpentier wanted to persuade the premier to commission Renoir to do the decoration of a large panel in the new Hôtel de Ville....

The necessity for dressing in formal evening clothes always annoyed him, and once he reached home, instead of changing his shirt, he saved time by putting on a strange combination of starched collar and false shirt front, quite a popular device at that time.

Upon reaching the Charpentiers' house, he solemnly handed his top hat, scarf, gloves and overcoat to the footman, and walked into the drawing room before the astonished footman could stop him. He was welcomed by a burst of laughter, and with good reason – for in his haste he had forgotten to put on his dinner jacket, and was only in his shirt sleeves. Charpentier was highly amused and, to make him feel at ease, took his coat off. All the other men did the same. Gambetta declared that it was very 'democratic'. And the dinner went on with an extra note of gaiety.

Jean Renoir
Renoir, My Father, 1958

Scandal at Dieppe

While Renoir was graciously welcomed by the Charpentiers and the Berards, some households found his presence jarring. This was the case with the Blanches, as shown in this letter the young painter Jacques-Emile Blanche wrote to his father, the famous psychiatrist Dr Emile Blanche, from Dieppe in July 1881.

Renoir came to see us yesterday. Mama had invited him, as you know, to come and work with me. Not having a room ready, we could not have offered him hospitality, and that's a good thing, as you'll see. Mama asked him to stay for dinner. We remained at the table just under three-quarters of an hour (usually we spend fifteen or twenty minutes). This made Mama so impatient that she said he made it impossible to have dinner with him. After having invited him, Mama sounded off about him, finding him lacking in wit, a dauber, a slow eater with unbearable nervous twitches. So, Mama is going to find a way to uninvite him. And she finds it amazing that I love the solitude of this house!…

Renoir painted a sunset in ten minutes. That exasperated Mama, who told him that he was only 'wasting paint'! It was fortunate that this fell on someone who never notices anything. As to me, I didn't say a word to Mama, I was so put out.

Jacques-Emile Blanche
in *La Pêche aux souvenirs*, 1949

At the soirées of Mallarmé and of Berthe Morisot

The poet Henri de Régnier wrote an introduction for a book of Renoir reproductions in which he recalled these two gatherings.

It was at Stéphane Mallarmé's that I saw Renoir for the first time.… My first impression was of a thin man with a thin face and an extremely nervous manner. I remember a face ravaged and intelligent, stamped with sensitivity, with observant eyes. Sober in attire and simple in demeanour, Renoir had just made a small portrait of Mallarmé, not a very good likeness, more of a mark of friendship between the painter and the poet than a finished work. Their relationship, if not intimate, was at least friendly, and had most probably been formed in Manet's studio, where Mallarmé, a regular, also knew Berthe Morisot, now Madame Eugène Manet.

It was at Berthe Morisot's that I met Renoir again. Mallarmé took me to the Rue de Villejust, where we often went

together on Sundays, after the concert. It was a strange place, of a rare distinction. Eugène Manet, Berthe Morisot and their daughter Julie lived in upper-middle-class style of impeccable taste. Eugène Manet, nervous and earnest, Berthe Morisot, with a haughty and cold courtesy, a remote elegance topped by her white hair, a sharp and sad look, and little Julie, a silent and wild child with naively coloured cheeks who from her beautiful Oriental eye gazed on the greyhound Laertes. They entertained in the living room– studio on the ground floor among the noble Empire furniture. Mallarmé repeated the discourse he had given in Belgium on Villiers de l'Isle-Adam.... Degas responded to Mallarmé. Teodor de Wyzewa contributed his Slavic subtleties. Renoir tore his bread apart in a gesture at once crude and rustic, with hands that were already deformed....

Henri de Régnier
in *Renoir, Peintre du Nu*, 1923

In perpetual motion

Thadée Natanson, founder of La Revue Blanche, *defended the avant-garde circles, both literary and artistic.*

A constant agitation hastens Renoir's stride, bows, then straightens his back, sets his twisted fingers moving, ceaselessly propels the frail, restive, irritable frame, lost in loose folds of clothes too large for it. It puckers his skin and makes every facial feature twitch, makes his eyelids flicker, focuses and quickens the nervous gesticulation of the body on the narrow mask: a ravaged face, shrunken, desiccated and drawn, and bristling with gray hairs, where the eyes sparkle, but kindly, above protruding cheekbones.

The nimble fingers constantly pluck and smooth the gray mustache and beard: sparse, rebellious hairs which put the finishing touches to an appearance which is forbidding at first sight, but promptly redeemed by the vivacity of the features and the goodness they express.

He comes and goes, sits down, stands up, has hardly stood up than he decides to sit down again, gets up and goes in search of the latest cigarette forgotten on the stool, no, not on the stool, or on the easel, no, on the table, not there either, and at last he decides to roll another which he may well loose before he has had the time to light it, but which is replaced by a third whose ash may have been cold for a day at least....

His working practice tolerates no audience, even of one, and his volubility is some measure of compensation for the silence his work demands. Once he has finished working, he always finds another means to talk passionately again about painting.

Thadée Natanson
'Renoir', *La Revue Blanche*, May 1896,
trans. in *Renoir: A Retrospective*,
ed. Nicholas Wadley, 1987

A father who did not blend in

After Jean Renoir was wounded in the First World War, he was finally able to get to know his father. They spent the long hours of his convalescence side by side, talking about the past.

When my father came to see me [at school], he seemed out of place among the other parents. His working jacket, with its buttoned-up collar; his hair, which was a little long under his soft felt hat, contrasted strangely with the

starched collars, dark silk cravats, waxed mustaches, and impeccably creased trousers of all the other fathers. Instinctively, they shunned this being from another world. While I was kissing him, I was embarrassed by the astonished looks of my schoolmates.

One Monday, after the first class was over and we were having a break, a boy named Roger came up and spoke to me. His father was head of a big grocery establishment in the section near the Opéra, and owned a villa at Trouville. As the last word in 'swank', his mother had had her appendix removed by the great surgeon Doyen. In short, they were people really in the swim. The other boys formed a circle around us. Roger took two sous from his pocket and held them out to me. 'Here,' he said. 'Give this to your father, and tell him to get his hair cut.'

I should have taken the money and thanked him for it. My parents had taught me that there was nothing shameful in accepting charity. But it was the first time I had ever heard my father criticized. I felt the blood rush to my head. For a fraction of a second the trees in the court and the faces around me blurred. Then I hurled myself on the blasphemer so fiercely that he was taken by surprise and did not have time to defend himself. He fell to the ground, but I kept on hitting him. I seized him by the throat, and would probably have choked him to death if two or three of the Brothers had not intervened. I was summoned

before the Prefect of Studies to explain my behavior. But he could make nothing of my story about my father's hair, so he sent me home for a few days to calm down. At least I got that much out of it. When I returned, I was agreeably surprised to find everyone very considerate towards me. Roger came and shook hands with me. 'You should have told me your father was an artist!'

Jean Renoir
Renoir, My Father, 1958

A snapshot in 1914

The poet Guillaume Apollinaire was also an art critic and an admirer of the old painter.

Yesterday I saw the latest photograph of Renoir, the greatest living painter. He is seated in a caned armchair in his studio; behind him are some canvases, turned around, to his left in the background, a country armoire. With his left hand, Renoir clutches the armchair, the right rests on his left knee. His legs are crossed, the left over the right. He wears black pants, grey jacket, dotted tie, bowler hat. His eyes sparkle, astonishingly expressive, and seem to absorb all the beauty of life.

Guillaume Apollinaire, in *Paris-Journal*, 13 July 1914

Renoir in 1900, when he was around sixty years old.

From the painter's eyes

His talent and his unaffected personality combined to win Renoir many painter-friends, both fellow Impressionists and younger artists.

Cézanne

The 'touchy master of Aix', Paul Cézanne, wrote in a letter of July 1902:

I despise all living painters, except Monet and Renoir.

Degas

Ambroise Vollard reported a presumed dialogue with Edgar Degas, who was critical of the practice of plein-air painting.

[Vollard]: But didn't Renoir, like Claude Monet, work outdoors?

Degas: it's not the same thing with Renoir; he could do whatever he

Auguste Renoir with Louis Valtat and Georges d'Espagnat (standing, pouring the absinthe), at Magagnosc, near Grasse, in 1900 or 1901.

wanted. You have seen a cat playing with balls of multicoloured yarn....
I will show you a Renoir that I have in my Paris studio; it has a sharpness of tones....

Degas suddenly became dreamy: 'Renoir,' he said, 'we don't see each other anymore!'

Ambroise Vollard
En Ecoutant Cézanne, Degas, Renoir
1938

Gauguin

This statement by Paul Gauguin was first cited in 1928, with no source given.

A painter who never knew how to draw but who draws well, that's Renoir....
In his painting...don't look for the line, it doesn't exist; like magic, a pretty spot of colour, a caressing light are sufficiently expressive. On the cheeks, as on a peach, a light fuzz ripples, animated by the breeze of love that speaks its music in the ears. One feels drawn to take a bite of the cherry that represents the mouth and, through the pearly laugh, the small, white, sharp child's tooth.

In Adolphe Basler
Pierre-Auguste Renoir, 1928

Monet

In a letter to Gustave Geffroy dated 8 December 1919, Claude Monet gave vent to his grief:

Renoir's death hits me like a painful blow. A part of my life vanishes with him, the battles and the enthusiasms of youth. It's truly hard. And here I am, the only one of the group left.

In Daniel Wildenstein
Claude Monet, biographie et catalogue raisonné, 1985

Bonnard

I had just illustrated a small book published by *La Revue blanche* [in 1898] with several brush drawings when I received a note from Renoir. I did not know him and I had never met him. Renoir wrote to me to say that he liked my drawings. You have a little touch of charm – do not neglect it. You will come across painters much bolder than you, but this gift is precious.... This is what Renoir wrote, more or less, to an unknown beginner.

I knew Renoir when he was still in good health. He had come to lunch with our group, as one of us, in a restaurant in the Place Clichy. Lean in a grey suit, and small hat, he was in a good mood and joked with us. I think he found us a bit too serious.

Later, I saw him at his atelier in the Rue Caulaincourt. Gabrielle was then the usual model, and unhappily, already nurse, as Renoir's hands were beginning to be affected. At noon, the friends who were there went off. Renoir had to go out himself, but lingered to talk. So Gabrielle: 'Come on, come and piss....'

When he was living in the Midi, where I spent some months, I would go and see him towards the end of the day, so as not to disturb him at work. I would find him smoking a cigarette while peering at the work in progress....

In his last years, he said to me suddenly one day, 'Is it not true, Bonnard, that we must embellish?'

This word could appear troubling to many people who think that to embellish is to introduce foreign formulas and aesthetics into the interpretation of one's vision. But Renoir has made for himself a magnificent universe. He has worked following nature and could project on to

a model and a light that might be a bit dull his recollections of more enthusiastic moments.

I thought of Renoir as a somewhat stern father.

Pierre Bonnard
'Souvenirs sur Renoir', *Comoedia*
18 October 1941

Matisse

'Renoir', Henri Matisse said, 'was interesting for more than just his painting.' Nonetheless, he was a great admirer of the older artist's work. He wrote a text for a catalogue to an Impressionist exhibition in Oslo; an extract follows.

Portraits of Renoir by Bonnard (c. 1916, left) and by Louis Valtat (c. 1904–5, opposite).

Renoir's nature, his modesty
as well as his confidence
in life, once the effort
was made, allowed him to
reveal himself with all the
generosity in his being, which
remained undiminished
by afterthoughts. Viewing
his work lets us see an artist
who has been blessed with
the greatest gifts, who has
had the gratitude to respect
them.

<div align="right">

Henri Matisse
Catalogue of a French art
exhibition, Oslo, 1918

</div>

Denis

*Maurice Denis, who made
several visits to the master
at Cagnes, recounted the
subterfuge Renoir used to get
a painting by Cézanne into a
collector's house. 'There is in
Cézanne a kind of asceticism which is also
to be seen in his art; Renoir did not have
such a rigid conception of life or painting,'
declared Denis.*

But Renoir admired Cézanne....
He liked to tell how he had got
Chocquet's first Cézanne in that
important collection into his home.
 Madame Chocquet intensely disliked
Cézanne's painting, so discretion was
called for. It was agreed that Renoir
would look after the picture that
Chocquet had just acquired and would
keep praising Cézanne in Madame
Chocquet's presence. 'So, my dear Renoir,
you are a great admirer of Cézanne's
painting?' 'I have a very fine one at
home,' replied Renoir. 'There are a few
faults but it is a beautiful thing.' 'Well
bring it tomorrow so we can see it.'

Renoir brought it several times
only to take it away again. At the
foot of the stairs Chocquet would say
to him: 'No, Renoir, not today, my
wife won't want to.' At last it was
shown, to Mme Chocquet's great
alarm. 'But Marie, Marie! it isn't
mine. You know perfectly well it
belongs to M. Renoir.' But Renoir
felt that the joke had gone on long
enough. He took advantage of
Chocquet's absence to tell his wife
everything. 'Pretend you didn't know,
you will make him so happy!' And
Cézanne's picture was finally hung
in the Chocquets' home.

<div align="right">

Maurice Denis
'Renoir', *La Vie*, 1 February 1920,
trans. in *Renoir: A Retrospective*
ed. Nicholas Wadley
1987

</div>

The critical reception

'I detest the critics, who cannot praise one artist without disparaging all the others.' In the course of his career, spanning more than a half-century, Renoir was the subject of many articles, some devastating. Still, in his lifetime he saw his work canonized and discussed as a chapter in the history of art.

CATALOGUE

DE

L'EXPOSITION DES ŒUVRES

DE

P.-A. RENOIR

9, BOULEVARD DE LA MADELEINE, 9

Ouverte du 1ᵉʳ au 25 Avril

The following mosaic of texts on Renoir is presented in chronological order.

Lise, the charming Parisian girl

Zacharie Astruc was linked with Manet, Bazille and Zola in the Batignolles school. It is not surprising, therefore, that he was among the first, in 1868, to mention the work of Renoir.

The *Lise* of M. Renoir completes an odd trinity that started with the very strange, powerfully expressive and notorious *Olympia*. In the wake of Manet, Monet was soon to create his *Camille*, the beauty in the green dress, putting on her gloves.… Here now is *Lise*, the most demure of them all. Here we have the charming Parisian girl, in the Bois, alert, mocking and laughing, playing the 'grande dame' somewhat gauchely, savoring the shade of the woods for all the agreeable diversions that may be had there: the dancing, the open-air café, the fashionable restaurant, the amusing dining room fashioned from a weird tree.…

It is an original image. The painting has great charms: beautifully rendered effects, a delicate scale of tones, a general impression that is unified and clear and well conceived lighting. The art that has gone into this painting seems simple, but in fact it is very unusual and very interesting. Given a subject whose whole charm is its light, it could hardly have been executed with greater clarity. The sunlit whites are delicious. Wherever the eye wanders, it is enchanted by the finest of nuances and very distinctive lightness of touch.

Zacharie Astruc,
'The Grand Style: Renoir', *L'Etendard*,
27 June 1868, trans. in *Renoir: A Retrospective*, ed. Nicholas Wadley, 1987

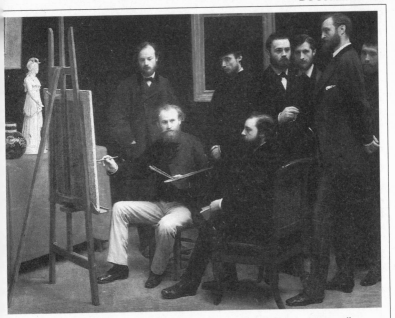

In 1870 Fantin-Latour painted, in homage to Manet (at the easel), *A Studio in the Batignolles,* which depicted from left to right the German painter Otto Schölderer, Renoir (with a hat on), Astruc, Zola, the musician Edmond Maître, Bazille and Monet.

The prodigal child of M. Gleyre

Arsène Houssaye, editor-in-chief of L'Artiste, *was a prolific writer. Administrator of the Comédie-Française and then inspector of the provincial museums, he was also one of the first to support Monet and Renoir.*

The two real masters of this school, which is concerned less with art-for-art's sake than nature-for-nature's-sake, are MM. Monet (not to be confused with Manet) and Renoir, two true masters, like Courbet of Ornans, by virtue of the brutal candor of their brush. I am told that the [Salon] jury has rejected Monet, but had the good sense to admit Renoir. This painter, as we see, has a fiery temperament, which bursts upon the scene brilliantly in a *Woman of Algiers,* which might have been signed by Delacroix.

His master, Gleyre, might well be surprised at having produced such a prodigal son, who mocks every rule of grammar by daring to do things in his own way. But Gleyre is too great an artist not to recognize art whatever its forms of expression.

So remember the names of M. Renoir and M. Monet. I have in my gallery the *Woman in a Green Dress* of Monet and an early bather of Renoir, which I shall present one day to the Luxembourg Museum, when the Luxembourg

Museum opens its doors to all painting without prejudice.

Arsène Houssaye
L'Artiste, 1 June 1870, trans. in *Renoir:
A Retrospective*, ed. Nicholas Wadley,
1987

'Romantic Impressionist'

Philippe Burty, author and art historian, was among the first to defend the Impressionists.

M. Renoir is certainly an Impressionist, but he would be more accurately characterized as a 'romantic Impressionist'. Highly sensitive in temperament, he is always afraid of being too assertive. By using the odd touch to emphasize all that is unmoving, in *Dancing at the Moulin de la Galette*, (chairs, benches, tables) he would leave the group of dancers and speakers a true sense of movement, the rays of sunlight their tremulous patches, and would imbue the whole scene with an air of reality which in fact is lacking. The drawing of the features in the portrait of our friend Spuller lacks solidity; but his expression is intense; the eyes think, the flesh is alive. The portraits of Mme Alphonse Daudet and Mme Georges Charpentier are true to life. The portrait of Mlle Samary renders the pretty face of a pert soubrette so well and so aptly evokes the particular stage atmosphere that one has to go back as far as the vivid sketches by Fragonard to find, not points of literal comparison, but similarities in the French temperament as applied to portrait painting.

Philippe Burty
'Exposition des Impressionnistes'
La République française, 25 April 1877
trans. in *Renoir: A Retrospective*
ed. Nicholas Wadley, 1987

An occasional art critic, Renoir contributed to the periodical *La Vie moderne*. He illustrated the cover of 1879 with a portrait of the genre painter Léon Riesener.

Canvases with rainbow colours

The writer Joris-Karl Huysmans was also one of the most personal of the art critics in the years 1880–90. L'Art moderne, *a collection of his critical essays, was published in 1883 by Georges Charpentier.*

Oddly enamoured of the reflections of the sun on velvet skin, the play of dancing sunbeams over hair and cloth, M. Renoir has bathed his figures in true sunshine, and it is something to see what adorable nuances, what fine rainbows come to light on the canvas! These paintings are surely among the most tasty of the Salon's offerings.

Joris-Karl Huysmans
'Le Salon Officiel de 1881'
L'Art moderne, Paris, 1883

'Visions as profound as those of Stendhal'

Octave Mirbeau quickly became the champion of the Impressionists, whom he defended brilliantly in his sarcastic and penetrating articles. A great art collector, he had a very fine collection of works by Monet and Van Gogh.

Whatever woman can evoke of grace, of tenderness, of seduction, of dreams and of coquetry; whatever she has of mystery and sickness; the indefinable in her look, as deep as the abyss, and the radiance of her skin, on which 'perfume prowls'; the sweetness of her eighteen years, blossoming with chaste desires and hopes; her melancholy moods, when she goes, slowly, her eyes circled with shadows, under the shadows of a park that make the purple shade of the leaves tremble and trail on her light dresses; her abandon when, with her back arched and her breast heaving, she leans her head, shivering and all blonde, on the shoulder of her partner in the waltz and lets herself be carried away; her attitudes of knowing inquiry and studied provocation, in the brilliant light of a theatre box, her eyes

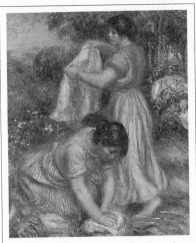

Washerwomen (c. 1912, above) and a study for *The Bathers* (c. 1886–7, below).

taking in everything while appearing lost in vacancy, her ears hearing all while seeming oblivious to murmured words, and her bare arm resting on red velvet, lying delicious and heavy, partly covered by the folds of her glove, and circled at the wrist by a dark gold bracelet; the peals of laughter from lips sparkling with pleasure and the infectious gaiety of an attractiveness she makes no attempt to conceal; the pains of disillusionments come too soon; the dream of an ideal that will never be realized; the misery of passion beginning, and the disgust of passion ending; the entire poem of love and cruelty that this cruel and charming creature recites; she who offers herself, who hides herself, who understands, who caresses. All this Renoir has understood, grasped, expressed. He is truly the painter of woman, sometimes gracious and emotional, sometimes wise and innocent, always elegant, with an exquisite sensitivity in her eyes, caresses

of the hand as light as kisses, visions as profound as those of Stendhal. He not only paints deliciously the physical forms of the body, the delicate patterns, the resplendent tones of the young carnations, he also paints the form of the soul, and that aspect of woman that expresses an internal *musicality* and a captivating mystery. His figures, unlike those by most modern painters, are in no way rooted in layers of paint; living and breathing, they sing the entire scale of clear tones, all the melodies of colour, all the vibrations of light.

Octave Mirbeau
'Renoir', *La France*, 8 December 1884

'The prettyish babbling bauble'

A friend of Gauguin and Emile Bernard and the person who discovered Van Gogh, Albert Aurier was a model Symbolist critic, who died too young.

In that immense and pretty toy bazaar that for him constituted the universe, it was naturally the tinted applelike cheeks, the invariably smiling red lips, the lovely enamelled, intensely blue eyes of dolls, adorable dolls, with pink porcelain flesh and shimmering satin finery, that especially and immediately attracted Renoir.

Woman, he wanted to paint woman, the exquisite, the prettyish babbling bauble, hopping and skipping, that he adored and whose soul, as he guessed, could not be after all very different from the works of a clock, sometimes a clock that had stopped…and, among all women, among all those sweet auto-matic amusements, among all those dainty artificial beings, it was those who had the most pronounced artificial character. The more obvious they were, the more they seduced him.…

Given such ideas, such a vision of the world and of femininity, it might be suspected that Renoir created a work that was merely *pretty* and merely *superficial*. Superficial – it is nothing of the kind. On the contrary, it is profound, for if, in fact, the artist has almost entirely suppressed the intellectuality of his models, he has compensated by throwing into his paintings all of his own intellectuality, and we shall see how exceptionally curious that intellectuality was.

As to the nature of *pretty*, it is, in his work, undeniable, but vastly different from the insupportable *pretty* that most fashionable painters exploit. Renoir's *pretty*, which is *pretty* pushed to the furthest limit of affectation, *pretty* par excellence and even impossible, becomes prodigiously interesting, first of all by its very excess and then because it is, in some way, a philosophical *pretty*, a symbolic *pretty*, symbolic of the soul of the artist, of his ideas, his cosmological beliefs.… Psychically organized as he appears to us, how, in effect, could he possibly perceive things and beings otherwise than with pretty outsides, since the only goal of beings and things seemed to him to charm, to be joyful, to amuse his child's soul, his artist's soul?

Albert Aurier
'Renoir', *Le Mercure de France*
August 1891

Painting: the corollary of vision

Faithful to Renoir, Octave Mirbeau offered a moving homage to the old painter on the occasion of a retrospective of his work held at the Galerie Bernheim-Jeune in 1913.

In this exhibition and this book containing his complete works year by

year we see Renoir as the equal even of those whose glory is firmly rooted in universal acclaim. And yet it is among us that he lives and paints, and lives. His painting is inseparable from the man himself. Other painters have set themselves problems, the great problems. They have given us sonorous meditations on the purpose and limits of life, the relation between art and life and the place of art in life and life in art. Esthetes, critics, philosophers, apostles and pedants all offer us an explanation of the world when they condescend not to save it. They have solved all the problems, as if life were a problem, as if there were some solution to life other than life itself, and as if a picture were something other than the happiness that it wrests from nature and gives to men. Renoir has been painting. And I can imagine the astonishment of the beautiful women and young poets. He has been painting, yes painting, in the true sense. Since when has a painter needed to paint?

Renoir paints as you or I breathe. For him, painting has become the corollary of vision. Other people's eyes cannot resist the temptation to wander. But with Renoir his hand has to set down in space the happiness he has seen with his eyes....

Renoir's work has devéloped by the year, by the month and by the day, as simply as a flower opens out its petals or a fruit ripens. Renoir has not given a thought of fulfilling his destiny. He has lived and painted. He has done his job. It is perhaps there that his genius lies. Furthermore, his whole life and work are a lesson in happiness. He has painted joyfully, with joy enough not to shout from the rooftops that joy in painting that sad painters proclaim lyrically. He

has painted women and children, trees and flowers with the admirable sincerity of a man who believes that nature is at the disposal of his palette as simply as if it had been created from all eternity to be painted....

Renoir is perhaps the only great painter who has never painted a sad picture.

<div style="text-align:right">

Octave Mirbeau
Renoir (exhibition catalogue), 1913,
trans. in *Renoir: A Retrospective*,
ed. Nicholas Wadley, 1987

</div>

Vollard: 'Renoir did my portrait'

The art dealer Ambroise Vollard is also known for his books about Cézanne, Degas and Renoir, among others. Georges Besson claimed that Renoir accused Vollard of grabbing witticisms on the wing and 'then rushing to his study to note them down'. The following text, first published in 1920, conveys his tone. Vollard is an unreliable witness, but his writings remain an important source – used with caution.

I had already sat for Renoir several times. He had made a lithograph and three oil studies of me, one of them quite finished, in which I am painted with my elbows resting on a table, holding a statuette by Maillol (1908).

With that I thought I was satisfied. But this was before Renoir did the portrait of Bernstein (1910), that canvas of such an extraordinary harmony in blue.

From that moment, my strongest wish was to have a portrait of me in the same harmony in blue.

Renoir agreed, but on one condition: 'As long as you wear a costume of a blue tone that means something to me; you know, Vollard, that metallic blue with the silvery sparkle.'

I thus gave myself over to blue; but to each new article of clothing that I found, Renoir told me, 'No, it's not right yet.'

In 1915, I spent several days at Les Collettes. I had forgotten about the portrait. As I was crossing the meadow of orange trees that line the road to the

house, I heard someone calling, 'Hey, Vollard!'

It was Renoir, returning from the countryside, carried in an armchair with handles by 'Big Louise' and Baptistin, the gardener. The model walked ahead, carrying the canvas.

The two porters stopped.

'Don't go so fast, Madeleine,' Renoir called to the model, 'I want to look at my painting.' To me: 'For a good fortnight I couldn't go out, and I had an awful need to freshen my vision.... I only had a few brushstrokes left to give my canvas, and I was counting on beginning something with Madeleine, but they'd forgotten to set up my umbrella. What a magician the sun is! One day, in the countryside around Algiers, with my friend [Lhôte], we

suddenly noticed a wonderful character astride a donkey. He came near. It was simply a beggar, but in the sun his rags looked like jewels.'

The model had placed the painting on the ground, against a tree.

'That's not bad is it?' Renoir said, with a little wink.... 'The trouble is that

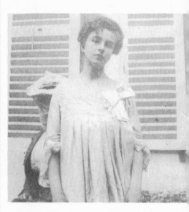

in the light of the apartment my canvas will look totally dark, but when I've been over it again in the studio, all its brightness will return!'

When we arrived at the studio: 'Vollard, call my "doctor"!'

And, seeing my bewilderment, 'I absolutely cannot get used to the word "nurse"!... Your hat is amazing! I have to do something with you.... Sit down on that chair.... You are in a truly peculiar light, but a good painter can work around every kind of light!...You don't know what to do with your hands; here, take hold of Claude's cardboard tiger or, if you prefer, that cat sleeping in front of the fireplace.'

I opted for the cat, and worked hard at winning its favour and was fortunate enough that, after purring a

moment, it fell asleep on my knees.

The 'doctor' was preparing the palette. Renoir named the colours, she pressed the tubes.

Once the palette was ready, and as the nurse was sliding the brush between his fingers, Renoir exclaimed, 'And my "thumb" that you've forgotten!'

'The delight which he communicates'

In 1910–2 the English painter and critic Roger Fry had two exhibitions of Impressionist paintings in London, which helped increase awareness of modern French art on this side of the English Channel.

A round 1901, on the Bernheim estate at Fontainebleau, Renoir executed outdoors a portrait of Suzanne Adler, who later became Madame Gaston Bernheim.

I could see my portrait being jeopardized; but the 'doctor' found the 'thumb' in the pocket of her apron.

Renoir always 'attacks' his canvas without seeming to take any thought for setting the scene. All you see are spots and more spots, until suddenly, amid these scrawls, a few strokes of the brush 'bring out' the subject. Even with his dead fingers, Renoir can still do a head in a single sitting, as before.

I could not lift my eyes from the hand that was painting. Renoir noticed: 'You can see, Vollard, that the hand is not essential for painting! The hand, that's crap!'

Ambroise Vollard
Auguste Renoir, 1920

More than any other great modern artist, Renoir trusted implicitly to his own sensibility; he imposed no barrier between his own delight in certain things and the delight which he communicates. He liked passionately the obviously good things of life, the young human animal, sunshine, sky, trees, water, fruit; the things that everyone likes; only he liked them at just the right distance with just enough detachment to replace appetite by emotion. He could rely on this detachment so thoroughly that he could dare, what hardly any other genuine modern has dared, to say how much he liked even a pretty sight. But what gives his art so immediate, so universal an appeal is that his detachment went no

R enoir dedicated this self-portrait 'To Vollard, my favourite bore'.

further than was just necessary. His sensibility is kept at the exact point where it is transmuted into emotion. And the emotion, through it has of course the generalised aesthetic feeling, keeps something of the fullness and immediacy of the simpler attitude. Not that Renoir was either naive or stupid. When he chose he showed that he was capable of logical construction and vigorous design. But for his own pleasure he would, as he himself said, have been satisfied to make little isolated records of his delight in the detail of a flower or a lock of hair.... Renoir...could trust recklessly his instinctive reaction to life.

Roger Fry
'Renoir', *Vision and Design*, 1920
in *Renoir: A Retrospective*,
ed. Nicholas Wadley, 1987

Cézanne, Renoir, women and sensuality

Maurice Denis was a painter, a theoretician and a great admirer of Renoir, who painted a portrait of his wife. After hearing the funeral oration for Renoir, he wrote a long text, concluding by contrasting the art of Cézanne with that of Renoir in the form of a manifesto, which he took up again in his book Nouvelles Théories *in 1922.*

Whereas Cézanne insists on his cubes, spheres and cylinders with the severity of a Spanish master, Renoir diverts himself by coaxing out invisible transitions between levels. The one is a great but clumsy decorator and logician; the other is a skilful sensualist who abandons himself to his imagination. 'Renoir,' Cézanne tells us with a hint of disdain, 'Renoir, well, what do you expect? He painted the Parisian women!' Cézanne's women, on the other hand, have never existed anywhere but in paintings in museums. The angles overlap, the objects sit upside down, but whether he copies or imagines, it all has a style; the painting is complete and, as Renoir says, he cannot place two dabs on a white canvas without it being *painting!* Both of them age well: their colour ripens. Renoir's bold gamut, his combinations of wine and brick red calm down and take on a golden hue. Cézanne takes on solidity, like a wall. Renoir's painting becomes as transparent as a lake, as shimmering as silk....

Art's goal is delight. Since Cézanne, our pleasure has been primarily intellectual. In the old aesthetic, intelligence and the senses were in no way opposed, nor the idea of the

painting against the imitation of nature. Let us hope to return to that fortunate time, and that Renoir's example will offer us the taste for the real and the feeling, for common sense and sanity. In the realm of art,

Là, tout n'est qu'ordre et beauté
Luxe, calme et volupté.

I am for order. But I find that by virtue of organizing polyhedrons, pipes, women without heads and faces without noses, by virtue of harmonizing clashing colours that are dirty and muddy, it becomes all too easy to forget the role sensuality plays in painting. And the luxury, the richness of that calling! The calm, the continuity in the effort! And, above all, the sensuality. That is what Renoir teaches.

Maurice Denis
'Renoir', 1 February 1920
in *Nouvelles Théories*, 1922

Barnes: expanding the boundaries

One of Renoir's greatest patrons, Albert C. Barnes, the American millionaire and art collector, wanted the world to know about the artist's unique abilities.

The vital importance in art of a constantly increasing capital of aesthetic meaning may be illustrated by a comparison of Monet's work with Renoir's. Because Monet's sensitivity and interest were practically restricted to the field of out-of-door light-and-colour effects, each new impact upon his sense called forth a type of reaction similar to previous reactions; selection and interpretation took place each time according to the monotonous dictates of his fixed set habits and limited background, and, correspondingly, failed to enrich the latter by expanding the boundaries of his vision.

Renoir too was interested in the impressionistic interpretation of nature and in Monet's technical method of expressing it; but the impact upon his senses, and his interpretation of what was being done by his contemporaries, instead of limiting his field of vision, quickened his sense of perception and broadened his insight. Thus the impressionistic form itself, in Renoir's hands, acquired a richer meaning because his keener perception and greater freedom of receptivity had discovered in it fuller possibilities than were ever suspected by its originators.

A set of landscapes by Monet offers great variety in subject-matter – especially in their character of illumination at different times of the day; but the essential quality expressive of the interaction of the scene with the man's personality is monotonously alike in all. Monet, in other words, was awake to only certain phases of life, beyond which his specialised vision seldom reached; Renoir, on the other hand, was continuously unfolding in his perception of Nature. He consistently inquired for, discovered, selected, established, organised and expressed new pictorial effects, connections, relationships, values and meanings, all reflecting a wide field of life activities, and a profound assimilation of the great traditions of painting. In contrast to Monet, Renoir could paint the very same spot of landscape a number of times and each version would reveal an essentially different ramification of his spirit and feelings.

Albert C. Barnes and Violette De Mazia
The Art of Renoir, 1935
in *Renoir: A Retrospective*,
ed. Nicholas Wadley, 1987

R enoir's paintings in the 1904 Salon d'Automne at the Grand Palais.

What is it about Renoir?

The influential 20th-century American critic Clement Greenberg examines his reactions to Renoir's paintings.

My reactions to Renoir keep changing. One day I find him almost powerful, another day almost weak; one moment brilliant, the next merely flashy; one day quite firm and the next merely soft. The extraordinary sensitivity of his pictures – even, and sometimes especially, the late ones – to the lighting under which they are seen has, I feel sure, something to do with this. Supposedly, the Impressionist aesthetic made lighting

LAIS — Salon d'automne
alle Renoir.
Série spéciale — 8 — A. B.

Renoir himself rather than to Impressionism.

I think part of the explanation may lie in the very special way in which he handled light and dark, making their contrasts seem just barely to coincide with contrasts of pure color; it may be for this reason that his contrasts tend to fade under a direct or bright light or when seen too near. But the un-Impressionist variety of Renoir's subject matter may also help to explain the fluctuations in one's response to the quality of his art. Landscape, still life, portrait, figure, group and even anecdote — he went from one to another easily and often, if not always with success. Even the best of his landscapes, which came around 1880, lack a certain finality, and so do the famous group scenes of earlier date. With the single figure, the still life and the flower piece — things he could see with an un-Impressionist closeness — he could at the same time succeed more consistently. On the other hand, some of the best pictures of his old age — and thus some of the very best of all his pictures — are group compositions....

Perhaps we are still too close to Renoir fully to appreciate [his] uniqueness. The current notion of what constitutes paint quality and highly finished painting derives very largely from his art, which in his own time was reproached, like that of the other Impressionists, for crudeness of *facture* and lack of finish; and this notion is a compromising one. At the same time, his method of high-keyed modeling has become a staple of academic modernism.

Clement Greenberg
'Renoir', *Art and Culture*, 1950
in *Renoir: A Retrospective*,
ed. Nicholas Wadley, 1987

and distance all-important factors in the viewing of a picture — but only supposedly. None of the Impressionists themselves seems actually to have made any more of a case about viewing conditions than artists usually do, and successful Impressionist pictures will generally declare their success under the same conditions as other successful pictures. That Renoir's should form such an exception would seem to be due to

MUSEOGRAPHY

All the great museums of the world own some works by Renoir. Among the most notable collections are those of the Musée d'Orsay, Paris; the National Gallery, London; the Pushkin Museum of Fine Arts, Moscow; the Hermitage, Saint Petersburg; the Nationalgalerie, Berlin; the Museum Folkwang, Essen; the Nationalmuseum, Stockholm; the Museu de Arte, São Paulo; the National Gallery, Washington, D.C.; the Art Institute of Chicago; the Boston Museum of Fine Arts; and the Philadelphia Museum of Art.

However, two of the artist's greatest masterpieces are housed in less-famous museums: *La Loge* (*The Box*) is in the Courtauld Institute Galleries, London, and *Luncheon of the Boating Party* is in the Phillips Collection, Washington, D.C. Finally, two extraordinary collections of Renoir's paintings are found in two lesser-known American museums: the Barnes Foundation in Merion, Pennsylvania, which has 180 works, and the Sterling and Francine Clark Art Institute in Williamstown, Massachusetts, which has more than thirty.

The Barnes Foundation, created in 1922, is more of an educational establishment than a true museum, following the wishes of its founder, Albert C. Barnes. His collection of French painting from the end of the 19th century and the beginning of the 20th, ranging from Manet to Matisse, is exceptional in both quantity and quality. For many years, it was shown only to students approved by the foundation and some visitors chosen by the founder and then by his heirs. Recently, as the buildings were being restored, the authorities who control the foundation allowed, for the first time, a selection of masterpieces that had never left the confines of the Barnes Foundation since their acquisition (for some of them, more than eighty years) to be exhibited in Washington, D.C., London, Paris, Tokyo and other venues.

The Sterling and Francine Clark Art Institute in Williamstown, Massachusetts, was founded in 1955 through the generosity of Sterling Clark, whose fortune is linked with the Singer sewing machine. Like Dr Barnes, Sterling Clark started forming his collection before the First World War and built it around 19th-century French, English and American art, as well as a selection of ancient art.

Two locations in France preserve the artist's memory. At Cagnes-sur-Mer, his house Les Collettes, in its original state, surrounded by hundred-year-old olive trees, houses a museum, with several works by the artist. It was created by the town in 1960 with help from the Committee for the Purchase and Artistic Use of the Renoir Estate and from the Alpes-Maritime Department.

At Chatou, on the island known as the Impressionists', the Fournaise restaurant has recently returned to its original function, and one can now lunch on the famous terrace overlooking the Seine, as in Renoir's time. This resurrection was made possible by the Association of the Friends of the Fournaise House and the municipality of Chatou, which set up a museum in the same building.

The island of Chiard at Chatou, on the banks of the Seine.

FURTHER READING

The following list includes only major works on the subject, all of which include excellent bibliographies.

GENERAL WORK
Rewald, John, *The History of Impressionism*, 1973

MONOGRAPHS
André, Albert, *Renoir*, 1919

André, Albert, and Marc Elder, *Renoir's Atelier*, 1989

Baudot, Jeanne, *Renoir, ses amis, ses modèles*, 1949

Daulte, François, *Auguste Renoir, Catalogue raisonné de l'oeuvre peint*, vol. 1: *Figures 1860–1890*, 1971 (future volumes are in the works)

Drucker, Michel, *Renoir*, 1944

Fezzi, Elda, *L'Opera Completa de Renoir nel Periodo Impressionista, 1869–1883*, 1972

Haesaerts, Paul, *Renoir: Sculptor*, 1947

House, John, Anne Distel, and Lawrence Gowing, *Renoir*, 1986

Meier-Graefe, Julius, *Auguste Renoir*, 1911

Pach, Walter, *Renoir*, 1964

Renoir, Jean, *Renoir, My Father*, 1958

Rivière, Georges, *Renoir et ses amis*, 1921

Vollard, Ambroise, *Tableaux, pastels, et dessins de Pierre-Auguste Renoir*, 2 vols., 1989

Wadley, Nicholas, ed., *Renoir: A Retrospective*, 1987

White, Barbara Ehrlich, *Renoir: His Life, Art, and Letters*, 1984

LIST OF ILLUSTRATIONS

CHAPTER 3

CHAPTER 4

DOCUMENTS

INDEX

ACKNOWLEDGMENTS

The author and publishers would like to thank the following people for their recollections of Charles Durand-Ruel: Mme Boulart, Isabelle Cahn, Claude Chambolle-Tournon, M. and Mme Jacques Chardeau, Alain Daguerre de Huraux, France Daguet, Guy-Patrice Dauberville, M. and Mme Déon, M. and Mme Philippe Durand-Ruel, Mme Escoffier, Jacqueline Georges-Besson, Caroline Godfroy Durand-Ruel, Gloria Groom, M. and Mme Guinard, Marla Hand, Steven Kern, Claude and Marc Le Coeur, Mme Robert Mayer, Christian Renaudeau d'Arc, Mme Rouart, and Antoine Terrasse.

PHOTO CREDITS

All rights reserved 15r, 16r, 21b, 25br, 31, 34, 40a, 44ar, 54r, 57l, 58, 59b, 70b, 79b, 99r, 129, 154, 166. Archives Durand-Ruel, Paris 76, 78, 84a, 88b, 113r, 115, 133, 139, 141, 145, 146, 149, 150. Archives Durand-Ruel, Paris/All rights reserved 123b, 128. Archives Durand-Ruel, Paris/Jean-Michel Routhier 84b. Archives Galerie Hopkins-Thomas, Paris 99l. Art Institute of Chicago 11, 38ar, 59a, 73, 77, 95. Artephot/Bridgeman 35. Artephot/Hachette 162. Artephot/Held 33a, 41a, 82, 110, 116l. Artephot/Nimatallah 111. Baltimore Museum of Art 97. Barnes Foundation, Merion, Penn. 54l, 70a, 72–3, 80, 88a, 96a, 107, 124–5, 125. Bibliothèque Nationale, Paris 42b, 44al. Bridgeman Art Library, London 28. Bulloz, Paris 116r. Carnegie Museum of Art, Pittsburgh 51. J.-L. Charmet, Paris 32, 41b, 71b, 96b, 98, 105, 156. Cleveland Museum of Art 17l, 17r, 102al. Collection Debuisson, Paris 164–5. Collection Durand-Ruel, Paris 114. Collection Sirot/Angel 50–1, 119, 160–1. Documentation, Musée d'Orsay, Paris 46a, 68–9, 138. Frick Collection, New York 45. Fundaçao Calouste Gulbenkian, Lisbon 39. Giraudon, Paris 20, 25l, 67b, 112a, 118. Giraudon/BL 142. Giraudon/Lauros 27. Harvard University Art Museums, Cambridge, Mass. 12, 13, 26, 47, 83l, 157b. Hiroshima Museum of Art 126b. Metropolitan Museum of Art, New York 64–5, 102ar, 102b, 108, 157a. Musée des Arts Décoratifs, Paris/L. Sully-Jaulmes 14b. Musée des Collettes, Cagnes-sur-Mer 106b, 123a. Musée Léon-Alègre, Bagnols-sur-Cèze 153. Museum of Fine Arts, Boston 86. National Gallery, London 33b, 89. National Gallery of Art, Washington, D.C. back cover, 30–1, 43, 50, 71a. National Museum of Wales, Cardiff 40b. Nationalmuseum, Stockholm 18l. Norton Simon Art Foundation, Pasadena, Calif. 49. Oskar Reinhart Collection, Winterthur, Switzerland 16l. Philadelphia Museum of Art 55, 94b. Phillips Collection, Washington, D.C. 74–5. Photo © Editions Gallimard, Paris 104a. Photo © Michael Tropea 104b. Photo Marianne Breslauer, Paris 124. Photothèque des Musées de la Ville de Paris © by SPADEM 1993 15l. Portland Art Museum, Oregon 38b. Private collection 19a, 19b, 25ar, 48, 56a, 62l, 62–3, 65, 66a, 66b, 68, 69, 92a, 120, 121, 140, 152. Réunion des Musées Nationaux front cover, spine, 1–9, 14a, 18r, 21a, 23a, 23b, 24, 36, 37, 42c, 44b, 46b, 52–3, 56b, 62r, 67a, 79a, 86–7, 87, 94a, 100, 101, 103, 109, 112b, 117a, 117b, 127, 130, 135, 155. Réunion des Musées Nationaux © by SPADEM 1993 122. Rijksmuseum Kröller-Müller, Otterlo 30. Roger-Viollet, Paris 85, 92b. Roger-Viollet/Harlingue 22. Scala, Florence 57r, 63. Staatliche Museum zu Berlin, Preussischer Kulturbesitz, National Galerie/Jörg P. Anders 29, 93. Sterling and Francine Clark Art Institute, Williamstown, Mass. 42a, 60, 61, 81, 83r, 90, 91, 113l. Studio Lourmel 77/Jean-Michel Routhier 38al. Virginia Museum of Fine Arts, Richmond 106a. Wadsworth Atheneum, Hartford, Conn. 126a.

TEXT CREDITS

Grateful acknowledgment is made for permission to use material from the following works:
(pp. 142–4: 'Renoir before his easel', 'From the sketch to the finished painting', 'Renoir and his models')
Albert André, *Renoir*, 1919, translation © Hugh Lauter Levin Associates. (p. 163: 'Barnes: expanding the boundaries') Albert C. Barnes and Violette de Mazia, *The Art of Renoir*, Barnes Foundation Press, 6th printing, 1986; used by permission of the publisher. (p. 153: 'Denis') Maurice Denis, *Du Symbolisme au classicisme*, Hermann Publishers, Paris. (pp. 161–2: 'The delight which he communicates') Roger Fry, *Vision and Design*, Chatto & Windus, London; reprinted by permission of the Estate of Roger Fry and the publisher. (pp. 164–5 'What is it about Renoir?') Clement Greenberg, *Art and Culture*, copyright © 1961 by Clement Greenberg; reprinted by permission of Beacon Press. (pp. 158–9: 'Painting: the corollary of vision') Octave Mirbeau, *Renoir*, 1913, Bernheim-Jeune & Cie., Paris; reprinted by permission of the publisher. (p. 141: 'Aphorisms on art'; p. 144: 'Jean Renoir in the studio'; pp. 146–7: 'A dinner at the Charpentiers'; pp. 148–9: 'A father who did not blend in') Jean Renoir, *Renoir, My Father*, copyright © 1958, 1962 by Jean Renoir; by permission of Little, Brown and Company. (p. 132: 'To Durand-Ruel: why send paintings to the Salon?') Pierre Auguste Renoir, 'Letters to his dealer, March 1881–February 1882'; reprinted by permission of Durand-Ruel & Cie., Paris.

Anne Distel,
senior curator of the Musée d'Orsay in Paris,
is a specialist in Impressionist painting.
She has collaborated on the organization and
catalogues of many exhibitions, including:
'Impressionism: A Centenary Exhibition' (Paris, New
York, 1974), 'Pissarro' (London, Boston, Paris,
1980–1), 'Homage to Monet' (Paris, 1980), 'Renoir'
(London, Paris, Boston, 1985), 'From Corot to the
Impressionists, Donations Moreau-Nélaton' (Paris,
1991), 'Seurat' (Paris, New York, 1991) and 'From
Cézanne to Matisse: Great French Paintings from the
Barnes Foundation' (Washington, D.C., Paris, Tokyo,
Ft. Worth, Toronto, Philadelphia, 1993–5).
In addition, she has published many articles and the
book *Impressionism: The First Collectors* (1990).

Translated from the French by Lory Frankel

First published in the United Kingdom in 1995 by
Thames & Hudson Ltd, 181A High Holborn,
London WC1V 7QX

Reprinted in 2000

English translation © 1995
Thames & Hudson Ltd, London

© 1993 Gallimard

British Library Cataloguing-in-Publication Data

A catalogue record for this book is available
from the British Library

ISBN 0-500-30058-5

Printed and bound in Italy
by Editoriale Lloyd, Trieste